FONDATION
BEYELER

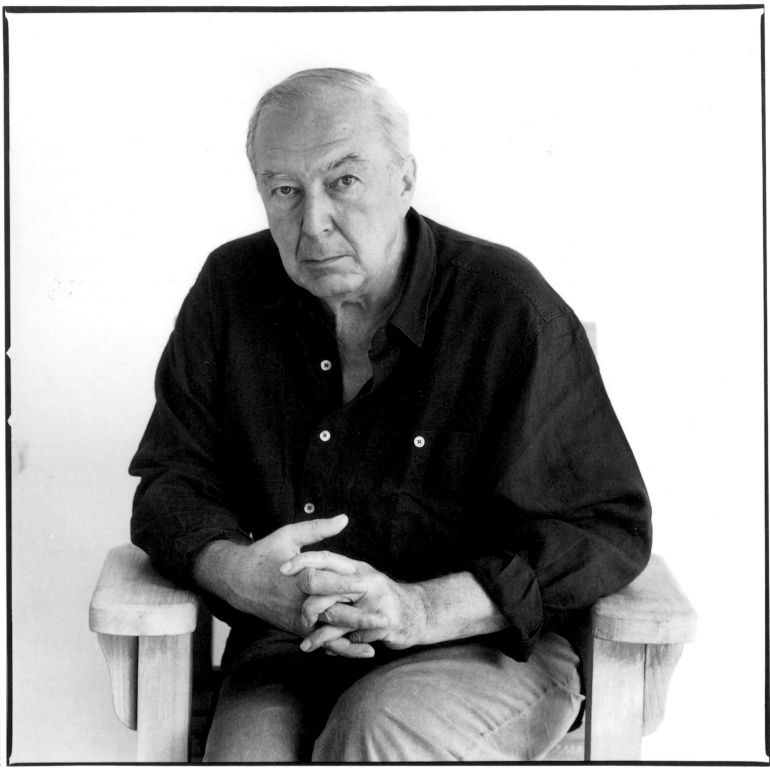

JASPER JOHNS

WERKE AUS DEM BESITZ DES KÜNSTLERS

mit einem Beitrag von Robert Rosenblum

LOANS FROM THE ARTIST

with an Essay by Robert Rosenblum

Dank

An dieser Stelle möchte ich Jasper Johns meinen
persönlichen Dank aussprechen. Durch seine
spontane Zusage wurde es möglich, dass wir unser
Museum in Riehen mit einer repräsentativen
Auswahl jener besonderen Werke eröffnen können, die
der Künstler für sich zurückbehalten hat. Grossen
Dank gebührt auch Kirk Varnedoe vom Museum of
Modern Art, New York, durch dessen Kooperation das
Projekt ermöglicht wurde, sowie seinen Mitarbeitern
Jennifer Russell für die Koordination, Michael Duffy
und Lilian Tone für die Installation in Riehen.
Wir danken auch Sarah Taggart vom Johns-Atelier
für ihre konstruktive Unterstützung.

Ernst Beyeler

Acknowledgement

I wish at this point to express my personal thanks
to Jasper Johns. His spontaneous acceptance made it
possible for us to open our Museum with a represen-
tative selection of those very special works he has kept
for himself. Sincere thanks also go to The Museum
of Modern Art, New York, for making this project
possible and to Kirk Varnedoe for his encouragement.
I wish to express my warmest thanks to Jennifer
Russell for coordinating the exhibition, to Michael
Duffy and Lilian Tone for their assistance with the
installation in Riehen and to Sarah Taggart of Jasper
Johns' studio for her constructive assistance.

Ernst Beyeler

Ausstellung: 21. Oktober 1997 bis 15. Februar 1998

ISBN-Nummer
3-905632-00-4

Inhalt
Contents

VORWORT

Jasper Johns gehört unbestritten zu den Schlüsselfiguren der amerikanischen Kunst der Nachkriegszeit. 1945/55, als der abstrakte Expressionismus in New York gerade seinen Höhepunkt erreicht hatte, malte der damals Vierundzwanzigjährige die amerikanische Flagge und zwar so, dass das Bild einerseits die gesamte Leinwand bedeckte und wie das reale Banner seines Heimatlandes an der Wand hing, andererseits als abstraktes Gemälde mit Sternen und Streifen lesbar war. Johns fasste auf einen Schlag die europäische konkrete Kunst und den abstrakten Expressionismus zusammen. Das Gemälde wies gleichzeitig in der einen Richtung der geometrischen Hard-Edge-Malerei und Minimal-Kunst den Weg und in der anderen der amerikanischen Pop-Art. Doch der Name «Johns» lässt sich nicht auf diese für die amerikanische Kunstgeschichte so zentrale Scheidemarke reduzieren. Ein äusserst komplexes, äusserst feingliedriges Werk, das kaum in kunsthistorischen Kategorien zu fassen oder auf eine Linie zu bringen ist, liegt heute vor uns. Es dokumentiert ein kontinuierliches Schaffen, hinter dem eine Künstlerpersönlichkeit steht, die das existentielle Abenteuer des Individuums im Zeitalter der anonymen Medien- und Massenproduktion im künstlerischen Prozess mit grosser Intensität bearbeitet. Nichts vermittelt vielleicht besser Einblick in diese Vorgänge als die Präsentation jener Werke, die der Künstler selbst für sich zurückbehalten hat.

Die Fondation Beyeler hat das Glück und auch die Ehre, ihre Sammlung und das von dem Architekten Renzo Piano errichtete Museumsgebäude mit einer erstmaligen Zusammenstellung von ausgewählten Arbeiten aus dem Besitz des Künstlers eröffnen zu können. «Jasper Johns – Loans from the Artist / Werke aus dem Besitz des Künstlers» ist gleichzeitig – zusammen mit der parallel stattfindenden Retrospektive von Renzo Piano – der Auftakt zu einem regelmässigen Programm von Wechselausstellungen, von denen zwei bis drei jährlich in speziell dafür vorgesehenen Räumen stattfinden. Es gehört zur Konzeption der Fondation, die aus Werken der klassischen Moderne bestehende Sammlung Beyeler von Anfang an in einen lebendigen Dialog mit der Gegenwart und mit Aspekten zu stellen, die in der Kollektion nicht explizit vertreten sind. Die auch im Umfang konzentrierte Schau soll das Eröffnungspublikum exemplarisch auf das Programm der Fondation einstimmen.

Die meisten Werke waren ebenfalls in der Retrospektive zu sehen, die Kirk Varnedoe vom Museum of Modern Art in New York zusammengestellt hat und die in diesem Jahr in Köln und Tokio gezeigt wurde. Die Ausstellung «Jasper Johns – Loans from the Artist» ist aber mehr, als bloss ein Extrakt aus dieser bisher grössten Überblicksschau. Ergänzt durch Zeichnungen, die Ernst Beyeler beim Künstler ausgesucht hat, bietet diese Zusammenstellung von rund 27 Öl- und Objektbildern und 25 Zeichnungen weniger einen «Überblick» als einen «Einblick» – und zwar einen konzentrierten Einblick in die bildnerische und gedankliche Werkstatt des Künstlers.

Man kann Spekulationen darüber anstellen, warum ein Künstler gewisse Kunstwerke nicht aus der

Hand gibt. Klee nannte solche Werke Arbeiten der «Sonderklasse», was für Johns gewiss auch gilt. Man kann sich darüber hinaus aber vorstellen, dass der Künstler an solchen Stücken immer wieder auch seine künstlerischen Methoden und seine Ideenwelt überprüft und dass er sie als Vorlage für neue, künftige Bilder bei sich haben will. Von Jasper Johns selbst bekommen wir keine direkte Antwort auf die Frage. Umso mehr sind wir aufgefordert, uns in die Ausstellung zu vertiefen und gerade anhand dieser von Johns selbst «verursachten» Anthologie nachzuspüren, was den Künstler beschäftigt und was den inneren Zusammenhang seines vielschichtigen Œuvres ausmacht. Wichtige Hinweise erhalten wir dabei im Katalogtext von Robert Rosenblum, für den wir uns beim Autor bedanken. Rosenblum erkennt in diesen gerade von unpersönlichen Mustern und anonymen Industrieprodukten bevölkerten Werken den unausweichlichen Zwang, sich der starken Präsenz des Künstlers bewusst zu werden: «Johns schwebt in seiner eigenen Kunst und schaut uns fast so an, wie wir versuchen, ihn anzuschauen». Daraus spricht die Suche nach Intensität, nach starken Bildern, für die das Gleiche gilt, was Reinhold Hohl einmal über die Sammlung Beyeler geschrieben hat: Es sind «starke, zum Teil „schwierige" (also nicht gefällige) Werke, die sozusagen ihr Bestes und Letztes hergeben und deshalb jedes für sich die volle Aufmerksamkeit verlangen».

Markus Brüderlin
Künstlerischer Leiter
Fondation Beyeler

FOREWORD

Jasper Johns is indisputably one of the key figures of postwar American art. In 1954/55, when Abstract Expressionism was at its height in New York, the then twenty four-year-old made a painting of the US flag and in such a way that the picture covered the entire canvas and hung on the wall like a genuine stars and stripes while it could at the same time be read as an abstract painting with stars and stripes. With that one work, Johns brought together European Concrete Art and Abstract Expressionism. What is more, he pointed the way not only towards geometric Hard-Edge Painting and Minimalism but also towards American Pop Art. Yet the name of Jasper Johns cannot be reduced to this one moment in the history of American art, significant a watershed as it was. What lies before us today is an exceedingly complex, exceedingly finely constructed œuvre that does not fit into established art historical categories or follow a single line. It testifies to the continuous creativity of an artist whose work explores with great intensity the existential adventure of the individual in this era of anonymous media and mass production. There is possibly nothing that can offer a better insight into these processes than the presentation of those works that the artist has retained for himself.

The Fondation Beyeler has the good fortune and also the honour to be able to open its collection and the museum building designed by the architect Renzo Piano with a selection of works lent by the artist. "Jasper Johns/Loans from the Artist" – together with the simultaneous Renzo Piano retrospective – is the first in a series of regular temporary exhibitions, of which two or three will be held each year in rooms especially designed for them. Part of the Fondation's philosophy is to ensure, from the very beginning, that there is lively interaction between the Modern Classics in the Beyeler Collection and contemporary art. This opening exhibition, with its concentrated scope, is intended to provide the public with an example of the Fondation's intentions.

Most of the Johns works on show here were included in the retrospective at The Museum of Modern Art in New York, which was curated by Kirk Varnedoe and shown in Cologne and Tokyo earlier this year. Yet the exhibition "Jasper Johns/Loans from the Artist" is more than a mere extract from that major retrospective. This collection of 27 paintings and 25 drawings, which includes additional works selected by Ernst Beyeler, offers us not so much an overview as a concentrated insight into Johns' creativity and ideas.

One can speculate about why artists keep particular works for themselves. Klee referred to such works as being in a "class of their own", which certainly also applies in Johns' case. One can, however, also imagine that the artist might use such works time and again as a yardstick against which to measure his artistic methods and his ideas, and that he might wish to keep them as a model for future pictures. Jasper Johns himself does not give us any direct answer to this question. We therefore have all the more reason to immerse ourselves in this exhibition and to take this anthology as a means to gain an insight into what

the artist's preoccupations are and how his multi-faceted œuvre hangs together as a whole. The text Robert Rosenblum has contributed to our catalogue, for which we wish to thank him here, gives us some important pointers. In these works peopled by impersonal patterns and anonymous industrial products, Rosenblum perceives an inescapable compulsion to become aware of the artist's strong presence: "Johns hovers within his own art, almost looking at us as we try to look at him". This comment highlights Johns'

search for intensity, his desire to create powerful pictures to which the remark Reinhold Hohl once made about the Beyeler Collection applies equally well: they are "powerful, 'difficult' works that best epitomize an artist's depth and demand a viewer's total concentration".

Markus Brüderlin
Artistic Director
Fondation Beyeler

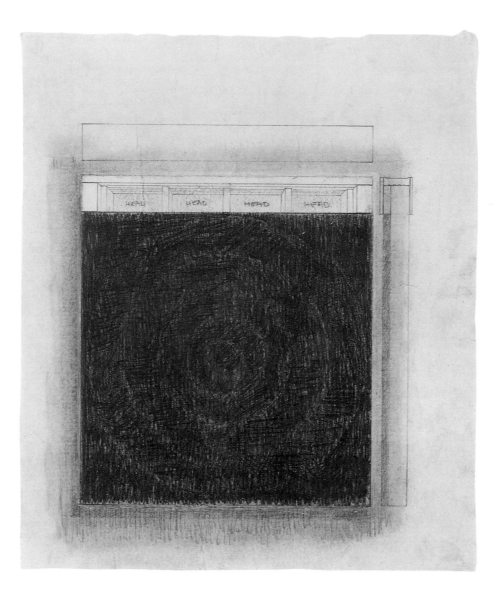

29 Target with Four Faces. 1955
 Zielscheibe mit vier Gesichtern. 23,5 × 20 cm

JASPER JOHNS
DAS REICH DER ERINNERUNGEN

von Robert Rosenblum

When this you see remember me. Gertrude Steins unvergessliches Sechs-Worte-Reimpaar resümiert nicht nur eine Fülle menschlicher Erfahrung, von Fotos und Postkarten bis zu Grabsteinen und Gemälden, sondern beschreibt auch die unheimliche Weise, auf die Jasper Johns' Kunst uns zwingt, uns ständig seiner Präsenz bewusst zu sein, sei es seines Körpers, seines Geistes oder seiner Gefühle. Mit endlos schöpferischen, offenen und verdeckten Überraschungen schwebt Johns in seiner eigenen Kunst und schaut uns fast so an, wie wir versuchen, ihn anzuschauen. Und wenn wir – wie hier – unser Augenmerk auf eine Anthologie von 52 zwischen Mitte der 50er Jahre und Mitte der 90er Jahre entstandenen Werken richten, die Johns für sich zu behalten beschlossen hatte, dann wird die Auswirkung ihrer Bedeutung für den Künstler weiter verstärkt. Die Parallele zu Picassos Privatsammlung liegt auf der Hand. Auch dieser behielt im Verlauf der Jahrzehnte zahlreiche Werke zurück, von denen wir annehmen müssen, dass sie für ihn eine besondere Bedeutung hatten, indem sie innere und äussere Wendepunkte in seinem Leben und in seiner Kunst markierten.

Einen guten Zugang zu Johns' Glasglocken-Welt der Selbsterforschung bietet ein Gemälde von 1964 (Nr. 9), die erste von zwei Versionen eines zusammengesetzten Bildes mit dem Titel *Souvenir*[1]. Auf direkteste und offensichtlichste Weise kann dieses Bild als konfrontierendes Selbstbildnis gesehen werden, in dem der Künstler sowohl sich selbst als auch den Betrachter anstarrt. Auf jede andere Weise sabotiert es jedoch alle Erwartungen der Selbstporträtierung. Zum einen ist das Bildnis des Künstlers, statt von ihm von Hand gemalt zu sein, ein Souvenir von einem Aufenthalt in Japan im Mai des genannten Jahres. Ein von Johns in einem Fotoautomaten in Tokio hergestelltes Foto von sich selbst wurde auf einen weissen Porzellanteller übertragen, der für diesen Touristen wie für zahllose andere ein Souvenir im wahrsten Sinne des Wortes darstellt. Aber diese Wiedergabe des Gesichts des Künstlers, die so unpersönlich wie ein Passfoto oder ein Bild in einem Schuljahrbuch ist, blickt uns mitten aus einer seltsam persönlichen Auswahl von Wörtern und Gegenständen an, die vorwärts und rückwärts in Johns' Leben und Kunst zu sondieren scheinen. So sind zum Beispiel dem japanischen Souvenir-Teller die Worte RED, YELLOW, BLUE hinzugefügt worden, die in einem unpersönlichen Stil (Schablonenschrift) ein Sinnbild (die drei Grundfarben) erzeugen, das sich ironischerweise als erkennbares Symbol für Johns' Arbeit erweist. Früher hatte er öfter in seine Werke diesen verbalen Bezug zur heiligen Dreieinigkeit der Malerpalette eingebettet, was ein ständiges Motiv blieb. Ähnlich wie in Picassos Kunst, wo das Vorhandensein einer Gitarre der Harlekin-Figur eine Projektion des Künstlers selbst darstellt, werden diese drei Worte - red, yellow, blue – nahezu zu einer Ersatz-Signatur für Johns[2]. Tatsächlich umgeben sie in diesem fotografischen Porträt sein Bild, als bildeten sie, wie die Attribute eines Heiligen, einen integrierenden Bestandteil seiner persönlichen Identität.

Aber wie bei Johns üblich, birgt *Souvenir* für den Betrachter wesentlich mehr Komplexitäten als das sofort erkennbare Selbstbildnis. Am Bild befestigt sind ein Rückspiegel und eine Taschenlampe, Gegenstände, die unter anderem nicht nur ein Vehikel heraufbeschwören, wie ein Fahrrad, dass sich durch Raum und Zeit (als Erinnerung an eine zurückliegende Reise) bewegt, sondern auch ein metaphorisches Bild der persönlichen Biographie, in der man sich zwischen dem Blick nach vorn (in der von der Taschenlampe markierten Richtung) und einer Reflexion dessen, was gestern war, bewegt. Selbst unter dem Gesichtspunkt einer imaginären Optik würde das Lichtbündel der Taschenlampe vermutlich auf den Spiegel fallen, der seinerseits so abgewinkelt ist, dass der Gegenstand dieser Reise, der Künstler selbst, beleuchtet wird, der aufgrund der unruhigen Schwärze der Enkaustik-Szene in der Nacht allein durch Erinnerungspfade zu reisen scheint. Und die Tatsache, dass in Johns' Arbeiten bereits 1958 eine Taschenlampe in einer Reihe von Plastiken, bei denen dieser Gebrauchsgegenstand wie einbalsamiert unbrauchbar gemacht worden war, als Motiv diente, verleiht *Souvenir* eine weitere retrospektive Komponente.

Obwohl *Souvenir* die physiognomische Präsenz des Künstlers banal in den Vordergrund stellt und auch subtil seine psychologische Aura beschwört, bleibt das Bild schwer fassbar und gibt uns das Gefühl, über ein geheimes Tagebuch uns den Kopf zu zerbrechen. Selbst wenn Johns buchstäblich seinen eigenen Körper gebraucht, wie er dies öfters tut, entzieht er sich ebenso unseren Bemühungen, irgend ein greifbares Ganzes zu fassen. Dies ist deutlich in einem Quartett von Kohlezeichnungen der Fall (Nr. 34, 35, 36, 37), die er 1962 zum Thema Haut geschaffen hatte, jener menschlichen Oberfläche, die Johns in seinen Skizzenbuchnotizen mit etwas in Beziehung gebracht hatte, das wie eine Leinwand gefaltet oder gebogen oder gezogen

werden musste[3]. Auch diese geisterhaften Zeichnungen strahlen Johns' physische Präsenz aus und machen gleichzeitig den Effekt eines greifbaren Gesichtes oder Körpers zunichte. Was wir effektiv sehen, sind die verschwommenen und wechselnden Abdrücke des Kopfes und der Hände des Künstlers auf Zeichenpapier, die wie Pauszeichnungen auf Grabtafeln aussehen. Das Ergebnis kann uns das Gefühl vermitteln, so nahe bei ihm wie der Atem auf einem Spiegel zu sein, aber gleichzeitig bietet es ihm die Möglichkeit, sich wiederum in nichts aufzulösen und Emanationen statt greifbare Tatsachen zurückzulassen.

Andere Künstler haben auf ihren Arbeiten Handabdrücke zurückgelassen, wie zum Beispiel Miró und Pollock, aber diese Ersatz-Signaturen vermitteln das Gefühl einer momentanen, physischen Energie, wie der Abdruck einer Ohrfeige, während Johns' Körperabdrücke wie geisterhafte Nachempfindungen aussehen, die so weit weg von der Realität sind wie ein fotografisches Negativ. Im Fall des fotografischen Porträts in *Souvenir* mit seiner nahezu ikonischen Frontalität und der heraldische Halo aus Worten[4] haben diese Zeichnungen, die mehr geistig als materiell zu sein scheinen, eine unerwartete religiöse Aura. Wir könnten hier sogar an christliche Reliquien von übernatürlicher Präsenz, wie das Schweisstuch der Veronika oder das Heilige Grabtuch von Turin[5], erinnert werden. Aber profaner gesehen, erfasst diese Gruppe von Zeichnungen die mysteriöse Weise, in der Johns immer nah und fern zu sein scheint, in seinem Werk beobachtet und beobachtend. Deren Aufnahme in seine persönliche Sammlung weist wiederum auf ihre besondere Rolle als Prüfsteine seiner Kunst und Persönlichkeit hin. Diese Phantom-Präsentation seines körperlichen Ichs fortsetzend, schuf Johns 1973 zwei weitere Kohle-Abdrücke von Teilen seines Körpers (Nr. 39, 40), die in diesem Fall buchstäblich die durch die Kohle nahezu unkenntlich gemachten

intimsten Teile, die Geschlechtsorgane und das Gesäss waren. Wie vorauszusehen war, wurden auch diese Blätter von Johns für sich behalten. Überdies könnten diese Bilder, wie die frühere Gruppe von Haut-Zeichnungen, insofern auch künstlerische und persönliche Erinnerungen aus früheren Zeiten wachgerufen haben, als sie an die ca. 1950 von Rauschenberg und seiner damaligen Frau Susan Weil durchgeführten früheren Experimente mit Körperbildern auf Blaupauspapier erinnern[6].

Bezeichnenderweise tauchen diese heimlichen Hinweise auf männliche Geschlechtsorgane in dieser Anthologie in verschiedenen Gestalten wieder auf, sei es im Gemälde *Painting with Two Balls* (Gemälde mit zwei Kugeln) von 1960 (Nr. 4), Johns' wohlbekannter Antwort in der Form eines visuellen Wortspiels auf den abstrakt-expressionistischen Macho-Mythos des "making a painting with balls" (das Äquivalent zu Cézannes *style couillard*) oder – 20 Jahre später – 1980 in einer Zeichnung und drei Gemälden mit dem Titel *Tantric Detail* (Nr. 46, 15, 16, 17), wo, wie Mark Rosenthal bemerkte[7], diese metaphorischen Testikel deutlich werden, obschon sie wiederum durch die symbolischen Anspielungen auf buddhistische Meditationen zu den Beziehungen zwischen Geschlecht und Tod von der anatomischen Unmittelbarkeit distanziert sind. Überdies werden sie Teil eines gespenstischen heraldischen Musters, das die reimenden runden Hohlräume der Augenhöhlen des darunter dargestellten Schädels aufnimmt, der über einer wirbelsäulenähnlichen Symmetrieachse schwebt. Wenn man sich an die drei Worte erinnert, die Johns' fotografisches Porträt in *Souvenir* umgeben, stellt man fest, wie bei der ersten der gemalten Versionen von *Tantric Detail* (Tantrisches Detail) (Nr. 15) die vorwiegend grauen, schwermütigen Schraffuren auf der linken Seite für einen Moment rot, gelb und blau aufleuchten, dann aber gedämpft werden und in der zweiten und dritten

Version (Nr. 16, 17) völlig verschwinden und knochenfarbene Töne in einem unterschwelligen Triumph des Todes langsam das ganze Feld beherrschen.

In einem Jahrhundert wie dem unseren, wo solche grossen, universellen Themen auszusterben drohen, ist es Johns gelungen, deren Geheimnisse wieder aufleben zu lassen und Visionen des Laufs der Zeit, des Dialogs zwischen Leben und Tod, Liebe und Kunst wieder bewusst zu machen. Wahrscheinlich die berühmteste dieser quasi-philosophischen Meditationen ist die vierteilige Reihe *The Seasons* (Die Jahreszeiten) (1985–86), die – charakteristisch für Johns - eine der gewöhnlichsten zyklischen Allegorien der westlichen Kunst in ein Quartett von privaten Tagebucheintragungen umsetzt, die voll von fragmentarischen Hinweisen auf seine eigenen Werke und diejenigen anderer Künstler sind[8].

Es ist wohl kein Zufall, dass er das Gemälde *Fall* (Herbst) (Nr. 21) für sich behalten hat, dessen Zeitpunkt der Entstehung seinem 56. Geburtstag am nächsten kam. Hier wird der Künstler wie in den anderen Gemälden durch eine nahezu ätherische Vision seines eigenen Körpers – nämlich durch seinen Schatten - dargestellt, den er effektiv projiziert, umrissen und zu einer Schablone verarbeitet hatte. In *Fall* ist dieser Schatten in zwei Teile aufgeteilt, was einen zeitlichen Übergang von der linken zur rechten Seite des Gemäldes heraufbeschwört. Und wie hinter geschlossenen Augen schweben Erinnerungen an andere Kunstwerke vorbei, seien es Arbeiten des Künstlers selbst (wie das Fragment der 26 nun in ihren Komplementärfarben Grün und Schwarz gemalten "Stripes" von zwei miteinander verbundenen amerikanischen Flaggen am unteren Rand) oder Werke von Duchamp (das schwebende Profil, das noch körperloser als Johns' Schatten ist) oder Picasso (wie der Schlagschatten selbst, der vom Gemälde *Der Schatten* von 1953 übernommen worden ist, oder die hier entzweigebrochene Leiter,

die in der Allegorie *Minotaurus beim Umzug* von 1936 eine wichtige Rolle spielt)[9]. Ferner wird dem zyklischen Ablauf der Jahreszeiten mit einem immer wiederkehrenden Johnsschen Motiv, einem sich bewegenden Kreis, der hier wie eine Uhr zu ticken scheint, ein weiterer Aspekt der Kreisförmigkeit hinzugefügt. Wie Kirk Varnedoe sagte: «Von statischen, der Fläche verhafteten geometrischen Figuren fand Johns schrittweise seinen Weg zu der Vorstellung einer kosmischen Ordnung der Zeit»[10]. Und nun stösst der wie ein Minutenzeiger einer Uhr um das Zentrum kreisende Pfeil auf eine ausgestreckte menschliche Hand, deren Fläche eine Grisaille-Version der Stigmen aufweist. Wir scheinen im vorletzten Moment in Johns' Leben und Kunst zu sein, deren Mitte überschritten ist und die der Realität des letzten Aktes entgegensehen. Dennoch schuf Johns drei Jahre später das ganze Quartett erneut als Tuschezeichnung auf einer langen Kunststofffolie, die er ebenfalls für sich behielt (Nr. 49), wobei er die Jahreszeiten in einer optimistischeren Reihenfolge (von links nach rechts: Sommer, Herbst, Winter, Frühling) anordnete, die auch die Kontinuitäten des primordialen Pulses von Leben, Tod und Erneuerung unterstreicht.

Es ist faszinierend zu sehen, wie oft das Thema von Kunst und Zeit und von Leben und Tod neu erfunden wird. Im Triptychon *Untitled (Red, Yellow, Blue)* (Ohne Titel [Rot, Gelb, Blau]) von 1984 (Nr. 19) tauchen die für den Künstler selbst so evokativen Worte für die Grundfarben – zwar oft versteckt – in den schattenhaften Schichten jeder Tafel auf. Und in jeder Tafel greift ein Etwas mächtig in das Bild hinein und verleiht der finsteren Grisaille-Feldern, wo diese abstrakten Farben begraben sind, Energie. In der ersten erscheint ein Richtungspfeil, der auch an den Zeiger einer Uhr erinnert, und kommt auch in den anderen Tafeln wieder vor. In der zweiten Tafel ist dieses Etwas in einen ausgestreckten Arm des Künstlers umstilisiert, und

in der dritten wird daraus ein Pinsel, eine Metapher, die man oft in Picassos metamorphischen Selbstbildnissen antrifft. Und in jeder Tafel gibt es Variationen des Kreises, eines der ältesten Motive Johns', das chronologische und zyklische Rhythmen heraufbeschwört. Zudem blicken diese runden Formen zurück auf die Zielscheiben, die zu einem seiner Erkennungsbilder der 50er Jahre geworden waren, sowie auf *Periscope (Hart Crane)* (Periskop [Hart Crane]) von 1963 (Nr. 7), das der Künstler ebenfalls für sich behielt, wo das schwarze Loch eines Kreises, das einen ausgestreckten Arm verschluckt, zugleich ein Abbild des Freitodes durch Ertrinken des homosexuellen amerikanischen Dichters Hart Crane und eine Darstellung seines poetischen Bildes eines Periskops ist, das aus der Tiefe des Wassers auftauchen und die Freuden und Leiden unseres vergangenen Lebens beobachten kann[11].

Eine noch unterschwelligere Variation dieses Themas ist die Reihe *Between the Clock and the Bed* (Zwischen Uhr und Bett) (1981–83). Diesen Titel hatte er von Munchs erschütterndem späten Selbstbildnis von 1940–42 übernommen, das dieser Künstler gemalt hatte, als er seinem achtzigsten Geburtstag entgegensah und sein Land unter der deutschen Besetzung litt[12]. Der betagte norwegische Künstler steht zwischen einer hohen Standuhr, die wir nahezu ticken hören, und seinem Bett, das mit einem Überwurf bedeckt ist, der das Schraffurmuster zeigt, das Johns bereits seit 1974 verwendete. Im rechten Teil des Schlafzimmers ist hinter einer Tür gerade noch eines der Gemälde eines weiblichen Aktes des Künstlers sichtbar, eine Erinnerung an die zwanghaft sexuelle Kraft, die seine frühe Lebens- und Schaffensperiode gekennzeichnet hatte. Typischerweise übersetzt Johns Edward Munchs hochemotionale Kontemplation über seine eigene Sterblichkeit in eine rätselhafte Sprache, die nahezu ausschliesslich auf dem abstrakten Schrägschraffur-Muster beruht, das für ihn zu einem grundlegenden

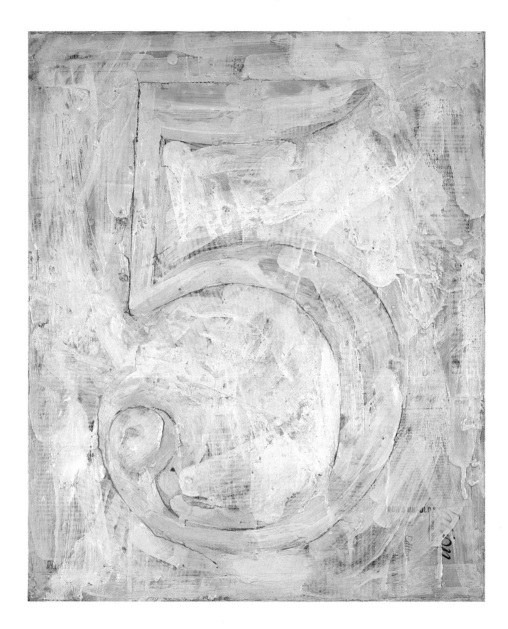

1 Figure 5. 1955
Ziffer 5. 44,5 × 35,6 cm

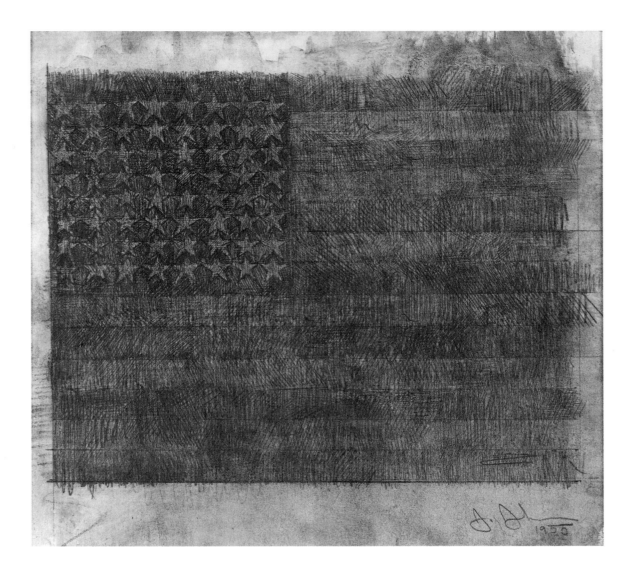

28 Flag. 1955
 Flagge. 21,5 × 25,7 cm

Ausdrucksmittel geworden war. In der Version von *Between the Clock and the Bed* von 1981, die er für sich behielt (Nr. 14), sind die in den drei Feldern des Triptychons vorherrschenden Schraffuren Gelb, Blau und Rot, Grundfarben, die auf der linken und mittleren Tafel ihre Komplementärfarben Purpur und Orange erzeugen und dadurch dem Gemälde einen unheimlich vitalen Schein verleihen, als ob es brennen würde. Das Feld rechts wird von einer fensterähnlichen Form unterbrochen, die vielleicht durch die weissen Türen und Türrahmen in Munchs Selbstbildnis inspiriert ist. Innerhalb dieses rechteckigen Rahmens wiederholt Johns das Schrägschraffur-Muster in einem wesentlich kleineren Massstab, wie wenn es sich in einem entfernten Raum hinter den Sprossen dieses Fensters befinden würde. Dabei ändern sich die Farben in eine blendende Helligkeit von Weiss gegen Schwarz, wie wenn plötzlich ein Blick durch eine Wand freigegeben worden wäre. Auf wundersame Weise wird der emotionale Gehalt in Munchs Gemälde mit seinem ergreifenden Kontrast zwischen Eingesperrtsein und Befreiung, Leben und Tod, in dieser abstrakten Sprache herausdestilliert, die gleichsam das Bild eines einsamen Künstlers vermittelt, der in seinem Atelier eingeschlossen ist, während von aussen eine andere Welt winkt.

Selbst über das überraschende Medium der entomologischen Illustration konnte sich Johns mit solch erhabenen Themen befassen. *Cicada* (Zikade), eine Aquarell- und Farbstiftzeichnung aus dem Jahr 1979 (Nr. 43) zeigt ebenfalls ein abstraktes Feld von Schrägschraffur-Mustern in den drei Grund- und den drei Komplementärfarben. Aber unten befindet sich eine Folge von Hieroglyphen über Leben und Tod, worunter Hinweise auf die seltsame Entwicklung der Zikade, eines Insekts, das nicht weniger als 17 Jahre im Erdboden lebt und hierauf in einer magischen Metamorphose als geflügelte Kreatur mit der erstaun-

lich kurzen Lebensdauer von einer Woche entschlüpft[13]. Aber abgesehen von Entomologie und Lebenszyklen, darf man nicht vergessen, dass das hypnotische Zirpen der Zikaden während ihrer periodischen Paarungszeiten für jemand wie Johns, der im Süden der Vereinigten Staaten aufgewachsen ist, wo diese Insekten stark verbreitet sind, eine lebendige Erinnerung sein muss.

Solche Träumereien über die Vergangenheit tauchen in Johns' Werdegang immer wieder auf und tragen dazu bei, zu erklären, wie er, wie Picasso, ein Bild von seiner Jugend jahrzehntelang immer wieder überarbeitete, um es auf subtile und augenfällige Weise zu ändern. Vom Bild, das zu seiner öffentlichen Signatur wurde, das Gemälde der amerikanischen Flagge von 1954–55, schuf er Dutzende von Variationen, die alle Ausdrucksmittel umfassen[14]. Eine der Versionen, die er für sich behielt, war die erstaunlich grosse *White Flag* (Weisse Flagge) von 1955 (Nr. 2), bei der die lebhaften Farben Rot, Weiss und Blau des ersten Auftauchens des Motifs in einen Schleier gehüllt sind, der das Bild in ein gelb-weisses Phantom seines ursprünglichen Selbst verwandelt. Und in einer kleinen Graphitstiftzeichnung einer Flagge von 1957 (Nr. 30) scheint das Bild, verdeckt durch eine dunkle, funkelnde Gaze, hinter geschlossenen Augen untergetaucht zu sein.

Aber diese Raum- und Gedächtnisschichten konnten in neueren Variationen des Flaggen-Themas nahezu wörtlich werden. 1994 änderte er einen Satz von Lithografien der Flagge von 1972, indem er ihren gedruckten Oberflächen eine weitere, handgemachte Flagge hinzufügte. Bei einer, die er für sich behielt (Nr. 52), verdunkelt oder begräbt die Flagge aus schwarzer Karborund-Tünche die darunterliegende, gedruckte Flagge fast vollständig und intensiviert so das Gefühl der Sterblichkeit und des Todes, welches das Spätwerk des Künstlers so stark verfolgt. Und

die Erinnerung an die Vergangenheit wird umso schmerzlicher, wenn wir feststellen, dass Johns die 48 Sterne der ursprünglichen Flagge beibehalten hat, die in den 50er Jahren nicht nur ein Symbol seines Landes war, sondern auch seines Hervortretens in diesem Jahrzehnt als berühmter junger Künstler. Später, in den 60er, 70er und 80er Jahren, änderte er seine Flaggen oft so, dass sie 50 Sterne enthielten, eine 1959 nach der Annexion von Hawaii und Alaska erfolgte offizielle Änderung, die seinen vor 1959 gemalten, gezeichneten und geformten Flaggen einen archaischen Anstrich wie jener der Flagge der Konföderierten Staaten von Amerika gaben. Aber hier griff er erneut auf das Bild der Flagge mit 48 Sternen zurück. Wie Hart Cranes Periskop zwingt sie uns, rückwärts zu blicken, um uns aus einer Distanz von nunmehr rund 40 Jahren an ein entferntes Jahrzehnt in der Geschichte der Nation und des Lebens und Schaffens des Künstlers zu erinnern.

[1] Für eine frühe, anschauliche Beschreibung dieses Werkes siehe den Katalog-Eintrag von C.L.Y (Christine L. Young) in J. Kirk T. Varnedoe, Hrsg., *Modern Portraits; the Self & Others*, New York: Wildenstein, 1976. Nr. 52.

[2] Man kann sich fragen, ob Barnett Newmans 1966 begonnene Reihe *Who's Afraid of Red, Yellow, and Blue?* nicht teilweise durch die Aneignung dieses chromatischen Trios durch den jüngeren Künstler ausgelöst worden sein könnte.

[3] Siehe John Russell und Suzi Gablik, *Pop Art Redefined,* New York: Praeger, 1969, S. 84.

[4] Es ist sogar eine Analogie zum abgeschlagenen, in einer Schüssel liegenden Haupt Johannes des Täufers vorgeschlagen worden. Siehe Barbara Rose, "Self-Portraiture: Theme with a Thousand Faces", *Art in America*, Jan.–Feb. 1975, S. 73.

[5] Wie von C.L.Y in Varnedoe, *s.o.*, Nr. 53.

[6] Siehe Walter Hopps, *The Early Rauschenberg; the 1950s*, Houston: The Menil Collection, 1991, Abb. 5–9.

[7] Mark Rosenthal, *Jasper Johns: Work Since 1974*, Philadelphia Museum of Art, 1988, S. 48.

[8] Für einige detaillierte Darstellungen von *The Seasons* siehe Judith Goldman, *Jasper Johns: The Seasons*, New York: Leo Castelli, 1987; Barbara Rose, "Jasper Johns: The Seasons", *Vogue*, Januar 1987, S. 192–99, 259–60; und Mark Rosenthal, *op. cit.*, S. 89–103.

[9] Über diese speziellen Entlehnungen von Picasso siehe Nan Rosenthal und Ruth E. Fine, *The Drawings of Jasper Johns*, Washington, D.C.: National Gallery of Art, 1990, Nr. 105; und Roberta Bernstein, «Der Anblick einer Sache kann manchmal dazu animieren, etwas anderes zu machen», in Kirk Varnedoe, Hrsg., *Jasper Johns Retrospektive*, München–New York: Prestel-Verlag, 1997, S. 56ff.

[10] Varnedoe, *op. cit.*, S. 27.

[11] Für die scharfsinnigste Besprechung von *Periscope (Hart Crane)*, was die Bedeutungen für den Künstler anbetrifft, siehe Kenneth J. Silver, "Modes of Disclosure: The Construction of Gay Identity and the Rise of Pop Art", in Donna de Salvo und Paul Schimmel, Hrsg., *Hand-Painted Pop; American Art in Transition, 1955–62*, Los Angeles: Museum of Contemporary Art, 1992, S. 184.

[12] Für einige faszinierende Bemerkungen über Johns' Beziehung zu Munch, siehe Judith Goldman, *Jasper Johns; 17 Monotypes*, West Islip: ULAE, 1982, Text ohne Seitenzahlen. Für weitere Kommentare über *Between the Clock and the Bed*, siehe Mark Rosenthal, *op. cit.*, S. 50–54.

[13] Für eine umfassende Besprechung der Geheimnisse von *Cicada* siehe Nan Rosenthal und Ruth E. Fine, *op. cit.*, Nr. 79.

[14] Für die umfassendste Anthologie dieser Variationen des Flaggen-Themas siehe *Jasper Johns Flags, 1955–1994* (with an essay *Saluting the Flags* by David Sylvester), London: Anthony d'Offay Gallery, 1996.

30 Flag. 1957
Flagge. 27,6 × 38,8 cm

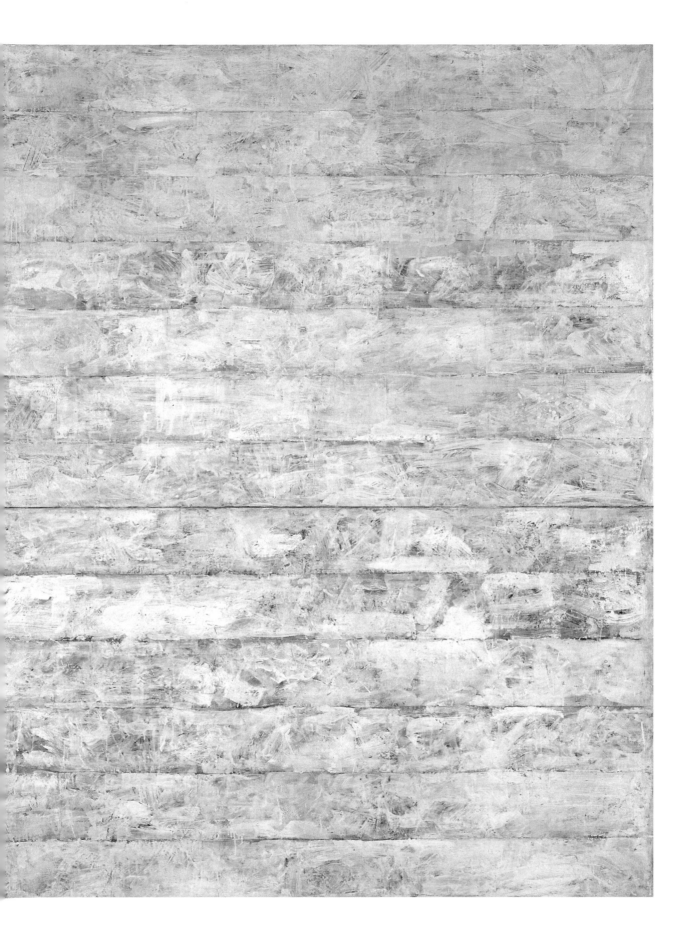

2 White Flag. 1955
Weisse Flagge. 198,9 × 306,7 cm

6 Painting bitten by a Man. 1961
 Gemälde, von Mann gebissen. 24,1 × 17,5 cm

JASPER JOHNS
THE REALM OF MEMORY

by Robert Rosenblum

When this you see remember me. Gertrude Stein's unforgettable six-word couplet not only sums up a wealth of human experience, from photographs and postcards to tombstones and paintings, but pinpoints the uncanny ways Jasper Johns's art obliges us to be constantly aware of his presence, whether of his body, his mind, or his feelings. In endlessly inventive surprises, both overt and covert, Johns hovers within his own art, almost looking at us as we try to look at him. And when we focus, as we do here, on an anthology of fifty-two works from the mid-1950s to the mid-1990s that Johns chose to keep for himself, then the implication of their significance to the artist is further intensified. The parallel with Picasso's private collection is inevitable. He, too, preserved for himself over the decades an abundance of works that we feel must have had special meaning for him, marking private as well as public turning points in his life and art.

A useful point of entry into Johns's bell-jar world of self-exploration is a canvas of 1964 (no. 9), the first of two versions of a composite image titled *Souvenir*.[1] In the most direct and obvious way, this can be read as a confrontational self portrait with the artist staring directly at himself as well as the viewer. But in every other way, it sabotages all expectations of self-portraiture. For one thing, the likeness of the artist, rather than being hand-painted by him, is, in fact, a tourist souvenir from a sojourn in Japan in May of that year. A mugshot of Johns, taken by the artist himself in a photo booth in Tokyo, has been transferred to a white china plate, providing this particular tourist, like

countless others, with a literal souvenir of a visit. But this rendering of the artist's face, as impersonal as a passport photo or an image in a high-school yearbook, looks at us blankly in the midst of a strangely personal assortment of words and objects that would probe backwards and forwards into Johns's life and art. For instance, the words RED, YELLOW, BLUE have been added to the Japanese souvenir plate, creating an emblem (the three primary colors) in an impersonal style (stenciling) that, ironically, turns into a recognizable symbol of Johns's work. Earlier, he had often embedded in his art this verbal reference to the holy trinity of a painter's palette and this would remain a persistent motif. Much as in Picasso's art, where the presence of a guitar of the figure of Harlequin would suggest a projection of the artist himself, so too do these three words – red, yellow, blue – become almost a surrogate signature for Johns.[2] Indeed, in this photo-portrait they encircle his image as if they were an integral part of his personal identity, like the attributes of a saint.

But as usual with Johns, *Souvenir* has far more complexities in store for the viewer than the instantly legible self-portrait image. Attached to the canvas are a rear-view mirror and a flashlight, objects that, among other things, evoke not only a vehicle, like a bicycle, moving through time and space (an appropriate souvenir of a distant voyage), but also a metaphoric image of personal biography, in which one hovers between a forward gaze (the direction marked by the thrust of the flashlight) and a reflection of what belongs to the past.

Even in terms of imaginary optics, the beam of the flashlight would presumably shine on the mirror, which, in turn, is angled at a position that would frame the subject of this voyage, the artist himself, who, judging from the agitated blackness of the painted encaustic setting, seems to be traveling alone, at night, through paths of memory. And the fact that a flashlight had already figured in Johns's work as a motif for a group of sculptures of 1958 in which this utilitarian object was rendered useless, as if embalmed, gives *Souvenir* a further layer of retrospection.

Although *Souvenir* boldly declares the artist's physiognomical presence and subtly conjures up as well his psychological aura, it remains characteristically elusive, making us feel as if we were puzzling over a secret diary. Even when Johns literally uses his own body, as he often does, he remains equally remote from our efforts to grasp clearly a tangible whole. This is conspicuously the case in a quartet of charcoal drawings he made in 1962 (nos. 34, 35, 36, 37) on the theme of skin, that human surface which Johns, in his sketchbook notes, had associated with something to be folded or bent or stretched, like what he might do to a canvas.[3] Again, these ghostly drawings radiate Johns's physical presence, while at the same time negating the effect of a palpable face or body. What we see, in fact, are the blurred and shifting impressions of the artist's own head and hands on sheets of drafting paper, like the rubbings taken from tombstones. The results may make us feel as close to him as the breath on a mirror, but at the same time they allow him to evaporate once more, leaving emanations rather than hard facts.

Other artists have left handprints on their work – Miró and Pollock, among them – but these surrogate signatures convey a sense of momentary, physical energy, like the imprint of a slap, whereas Johns's body prints look like disembodied after-images, as distant from reality as a photographic negative. As in the case of the photo-portrait in *Souvenir*, with its almost iconic frontality and heraldic halo of words[4], there is an unexpected religious aura about these drawings that seem more spirit than body. We may even be put in mind here of such Christian relics of a supernatural presence as Veronica's veil or the Holy Shroud of Turin.[5] But in more secular terms, this group of drawings captures the mysterious way in which Johns always seems to be both near and far, observed and observing in his work; and their inclusion in his personal collection again points to their particular role as touchstones of his art and personality. And continuing this phantom presentation of his corporeal self, in 1973 he made two more charcoal impressions of portions of his body (nos. 39, 40), in this case what were literally the most private parts, genitals and buttocks, camouflaged to near invisibility by the charcoal smudges. Almost predictably, these, too, were retained by Johns. Moreover, like the earlier group of "Skin" drawings, these may also have evoked long-ago artistic and personal memories, insofar as they recall the early experiments of body images on photographic blueprint paper made c. 1950 by Rauschenberg and his then wife Susan Weil.[6]

Typically, these clandestine references to male sexual organs resurface in different guises in this anthology, whether in the 1960 *Painting with Two Balls* (no. 4), Johns's well-known retort, in the form of a visual pun, to the macho Abstract Expressionist myth of making a "painting with balls" (the equivalent of Cézanne's *style couillard*); or, twenty years later, in 1980, in a drawing and three paintings titled *Tantric Detail* (nos. 46, 15, 16, 17), where, as Mark Rosenthal observed[7], these metaphoric testicles become explicit, although distanced once more from anatomical immediacy by the symbolic allusions to Buddhist meditations on the relation between sex and death. Moreover, they become part of a ghostly heraldic pattern

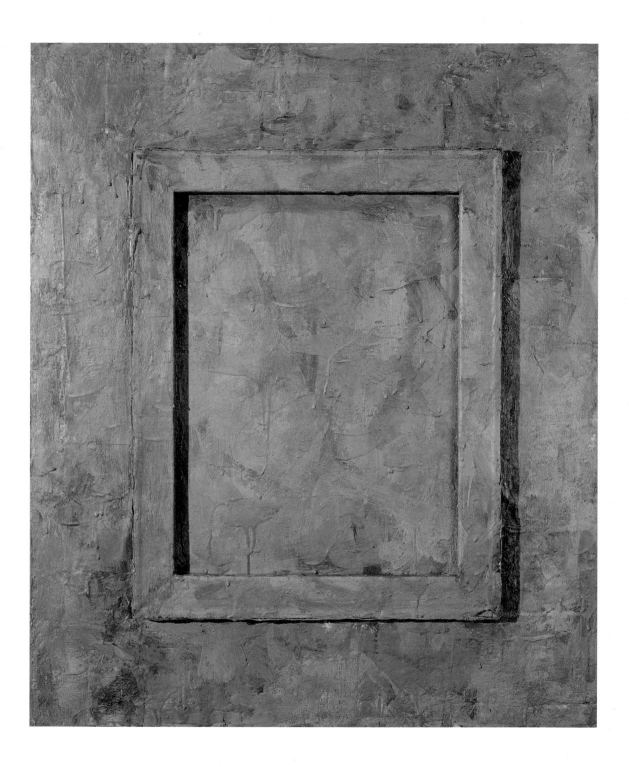

3 Canvas. 1956
Leinwand. 76,3 × 63,5 cm

33 Two Flags. 1960
 Zwei Flaggen. 74,9 × 55,2 cm

that includes the rhyming circular voids of the eye sockets in the skull below that floats over a spine-like axis of symmetry. Remembering the trio of words encircling Johns's photo-portrait in *Souvenir*, one notices how in the first of the painted versions of *Tantric Detail* (no. 15), the predominantly grey, lugubrious hatchings flicker for a moment into red, yellow, and blue at the left, but then become muffled and are finally extinguished in the second and third versions (nos. 16, 17) as a bone-white tonality slowly pervades the whole field in a subliminal triumph of death.

In a century like ours, when such grand, universal themes have become an endangered species, Johns has managed to resurrect their mysteries, reawakening visions of the passage of time, of the dialogues between life and death, love and art. Probably the most famous of these quasi-philosophical meditations is the four-part series, *The Seasons* (1985–86), which, characteristically for Johns, translates one of the most common cyclical allegories of Western art into a quartet of private diary entries, riddled with fragmentary references to his own and other artists' works.[8]

It was almost to be expected that of the four seasons, he would choose to keep *Fall* (no. 21), the point in the cycle that corresponded most closely to his own age, fifty-six, at the time of its creation. Here, as in the other paintings, the artist is represented by an almost ethereal vision of his own body, namely, his shadow, which he had actually projected, outlined, and turned into a template. In *Fall*, this shadow is split in two, evoking a passage in time from the left to the right of the painting. And as if behind shut eyes, remembrances of other art float by, whether of the artist's own work (such as the fragment on the lower edge of the twenty-six stripes of two paired American flags, now painted in their complementary color and value, green and black), of work by Duchamp (the hovering profile, even more disembodied that Johns's

shadow), or by Picasso (such as the cast shadow itself, quoted from a 1953 painting, *The Shadow*, or the ladder, here broken in two, that figures prominently in the 1936 allegory, *Minotaur Moving His House*).[9] And the cyclical progression of the seasons is given a further layer of circularity in the fragmentary presence of a recurrent Johnsian motif, a moving circle that here seems to tick like a timepiece. As Kirk Varnedoe put it, "From flat, static geometric devices, Johns found his way stepwise to the idea of a cosmic order of time."[10] And now, the concentric arrow, like the minute hand of a clock, pushes in the direction of an outstretched human hand that, on its palm, bears a grisaille version of the stigmata. We seem to be at a penultimate moment in Johns's life and art, over the midway mark and facing the realities of the last act. Nevertheless, three years later, in an ink drawing that Johns also kept for himself (no. 49), he recreated the entire quartet of paintings on one long sheet of plastic, arranging them in a more optimistic sequence (reading from left to right: summer, fall, winter, spring) that also underlines the continuities of this primordial pulse of life, death, and regeneration.

It is fascinating to see how often the theme of art and time, of life and death is reinvented. In the triptych *Untitled (Red, Yellow, Blue)* of 1984 (no. 19), the words for the primary colors, so evocative of the artist himself, are presented, though often almost entirely concealed, in the shadowy layers of each panel. And in each panel, a large, thrusting shape plunges through the edge, energizing the murky, grisaille fields where these abstract colors are buried. In the first panel, a directional arrow, also suggesting the hand of a clock, appears, and recurs in the other panels; in the second panel, this shape is stylized into the outstretched arm and hand of the artist; and in the third, the artist's working limb is transformed into a paintbrush, a metaphor often found in Picasso's metamorphic self-portraiture.

And within each panel, there are variations upon the circle, one of Johns's oldest motifs, that conjure up chronological and cyclical rhythms. Moreover, these circular forms also look back to the targets that had become one of his signature images of the 1950s and to *Periscope (Hart Crane)* of 1963 (no. 7), also preserved by the artist, where the black-hole of a circle that swallows an outstretched arm and hand is at once an image of the gay American poet's suicide by drowning and a rendering of his poetic image of a periscope that could rise from submerged depths and survey the joys and sorrows of one's past life.[11]

Still more subliminal a variation on this theme is the series of variations, *Between the Clock and the Bed* (1981–83), a title borrowed from Munch's harrowing late self-portrait of 1940–42, painted as the artist approached his eightieth birthday and as his country suffered under the Nazi occupation.[12] The aged Norwegian artist stands between a tall grandfather clock we can almost hear ticking and his bed, covered with a blanket that bears the hatch pattern Johns had already been using since 1974. To the right of the bedroom, one of the artist's paintings of a female nude is just visible behind a door, a reminder of the obsessive sexual force that marked his early life and art. Characteristically, Johns thoroughly translates Munch's emotionally high-pitched contemplation of his own mortality into a cryptic language defined almost exclusively by the abstract hatch pattern that had become for him a basic pictorial alphabet. In the 1981 version of *Between the Clock and the Bed* that he kept for himself (no. 14), the predominant hatch marks across the three fields of the triptych are yellow, blue and red, primaries that, in the left and center panels, generate their complementary hues, purple and orange, giving the painting an uncannily vital glow, as of a burning energy. At the right, this field is broken by a window-like shape, perhaps inspired by the white doors and door frames in Munch's self-portrait. Within this rectangular frame, Johns recreates the hatch pattern on a much smaller scale as if it were in a remote space beyond the horizontal bars. And the colors change into a blinding luminosity of white versus black, as if a vista beyond the enclosing wall were suddenly unveiled. Miraculously, the emotional charge of Munch's painting, with its poignant contrast of confinement versus release, of life against death, is distilled in this abstract language, which somehow conveys the image of a lone artist in his studio with another world beckoning outside.

Even through the surprising medium of entomological illustration, Johns could deal with such lofty themes. *Cicada*, a 1979 watercolor and crayon drawing (no. 43), also presents an abstract field of hatch patterns in the three primary and three complementary colors; but below, it offers a sequence of hieroglyphics about life and death that include references to the strange evolution of the cicada, an insect that lives underground for as long a period as seventeen years and then, in a magical metamorphosis, emerges anew as a winged creature with the startlingly brief life span of a week.[13] But entomology and life cycles aside, it should also be recalled that the hypnotic sounds of cicadas during their periodic mating seasons must have been an intense memory for someone who, like Johns, was raised in the Southern United States, where these insects proliferate.

Such reveries upon the past recur throughout Johns's career and help to account for the way in which, like Picasso, he would rework, decade after decade, an image from his youth, altering it in both subtle and obvious ways. Of the image that became his public signature, the painting of an American flag of 1954–55, he made dozens of variations in every medium[14]. Of those he kept, one was the startlingly large *White Flag* of 1955 (no. 2), which immediately casts a shroud over the vivid red, white, and blue of the motif's first

32 Thermometer. 1960
Thermometer. 55,9 × 27,6 cm

appearance, transforming it into a yellow-white ghost or skeleton of its former self. And in a small graphite drawing of a flag of 1957 (no. 30), the image seems submerged behind closed eyes, discerned, as it were, through a dark and twinkling scrim.

But these layers of space and memory could become almost literal in more recent variations on the flag theme. In 1994, he altered a set of lithographs of the flag dating from 1972 by adding to their printed surfaces another handmade flag. In one that he retained (no. 52), the black carborundum wash flag on the new surface almost eclipses or buries the earlier printed flag, intensifying the sense of mortality and death that haunts so much of the artist's recent work. And the memory of the past becomes all the more poignant when we notice that Johns has preserved the forty-eight stars of the original flag that was a symbol not only of his country in the 1950s but of his emergence in that decade as a famous young artist. Later, in the 1960s, 70s, and 80s, he would often alter his flags to include the new field of fifty stars, a change officially effected in 1959 with the annexation of Hawaii and Alaska and a change which immediately gave the flags he painted, drew, and sculpted before 1959 an archaic flavor, like that of the confederate flag. But here, once more, he reverted to the original forty-eight-starred image of the flag. Like Hart Crane's periscope, it obliges us to look backwards, remembering at a distance of now some forty years a remote decade in the history of the artist's nation, life, and work.

[1] For an early lucid description of this work, see the catalogue entry by C.L.Y. (Christine L.Young) in J. Kirk T. Varnedoe, ed., *Modern Portraits; the Self & Others*, New York: Wildenstein, 1976, no. 52.

[2] One wonders, incidentally, whether Barnett Newman's series, *Who's Afraid of Red, Yellow, and Blue?*, begun in 1966, might not have been partially triggered by the younger artist's appropriation of this chromatic trio.

[3] See John Russell and Suzi Gablik, *Pop Art Redefined*, New York: Praeger, 1969, p. 84.

[4] An analogy with the decapitated head of St. John the Baptist on a plate has even been suggested. See Barbara Rose, "Self-Portraiture: Theme with a Thousand Faces", *Art in America*, Jan.–Feb.1975, p. 73.

[5] As proposed by C.L.Y., in Varnedoe, *op. cit.,* no. 53.

[6] See Walter Hopps, *The Early Rauschenberg; the 1950s*, Houston: The Menil Collection, 1991, figs. 5–9.

[7] Mark Rosenthal, *Jasper Johns: Work Since 1974*, Philadelphia Museum of Art, 1988, p. 48.

[8] For some detailed accounts of *The Seasons*, see Judith Goldman, *Jasper Johns: The Seasons*, New York: Leo Castelli, 1987; Barbara Rose, "Jasper Johns: The Seasons", *Vogue*, January 1987, pp. 192–99, 259–60; and Mark Rosenthal, *op. cit.*, pp. 89–103.

[9] On these particular borrowings from Picasso, see Nan Rosenthal and Ruth E. Fine, *The Drawings of Jasper Johns*, Washington, D.C.: National Gallery of Art, 1990, no. 105; and Roberta Bernstein, "Seeing a Thing Can Sometimes Trigger the Mind to Make Another Thing", in Kirk Varnedoe, *Jasper Johns: A Retrospective*, New York: The Museum of Modern Art, 1996. pp. 57ff.

[10] Varnedoe, *op. cit.*, p. 29.

[11] For the most penetrating discussion of *Periscope (Hart Crane)* in terms of its personal meanings for the artist, see Kenneth J. Silver, "Modes of Disclosure: The Construction of Gay Identity and the Rise of Pop Art", in Donna de Salvo and Paul Schimmel, eds., *Hand-Painted Pop; American Art in Transition, 1955–62*, Los Angeles: Museum of Contemporary Art, 1992, p. 184.

[12] For some fascinating observations on Johns's relationship to Munch, see Judith Goldman, *Jasper Johns; 17 Monotypes*, West Islip: ULAE, 1982, unpaginated text. For further comments on *Between the Clock and the Bed*, see Mark Rosenthal, *op. cit.*, pp. 50–54.

[13] For a full account of the mysteries of *Cicada*, see Nan Rosenthal and Ruth E. Fine, *op. cit.*, no. 79.

[14] For the fullest anthology of these variations on the flag theme, see *Jasper Johns Flags, 1955–1994* (with an essay *Saluting the Flags* by David Sylvester), London: Anthony d'Offay Gallery, 1996.

31 Study for "Painting with a Ball". 1958
Studie für «Gemälde mit Kugel». 50,8 × 45,7 cm

4 Painting with two Balls. 1960
Gemälde mit zwei Kugeln. 165,1 × 137,2 cm

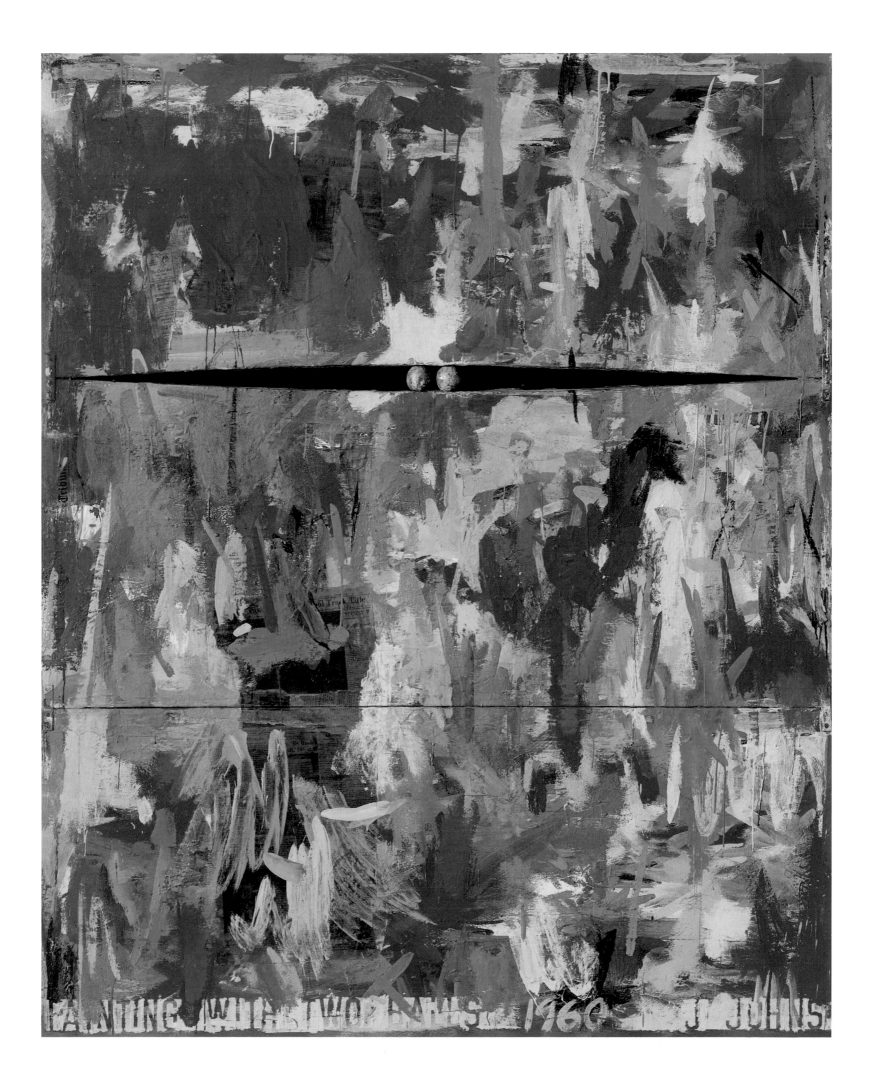

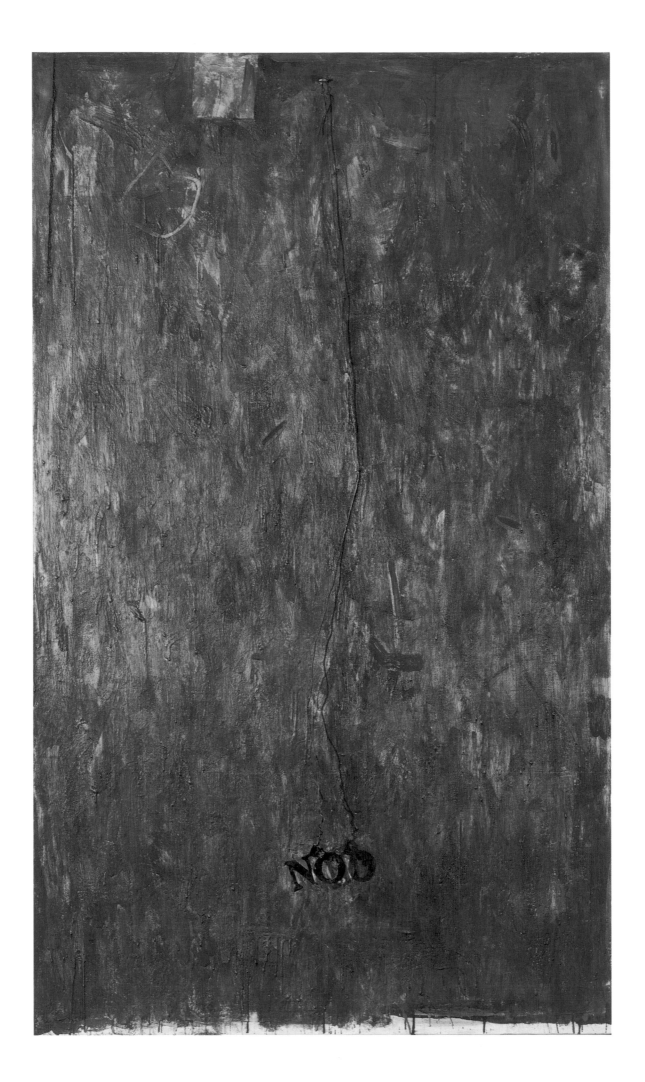

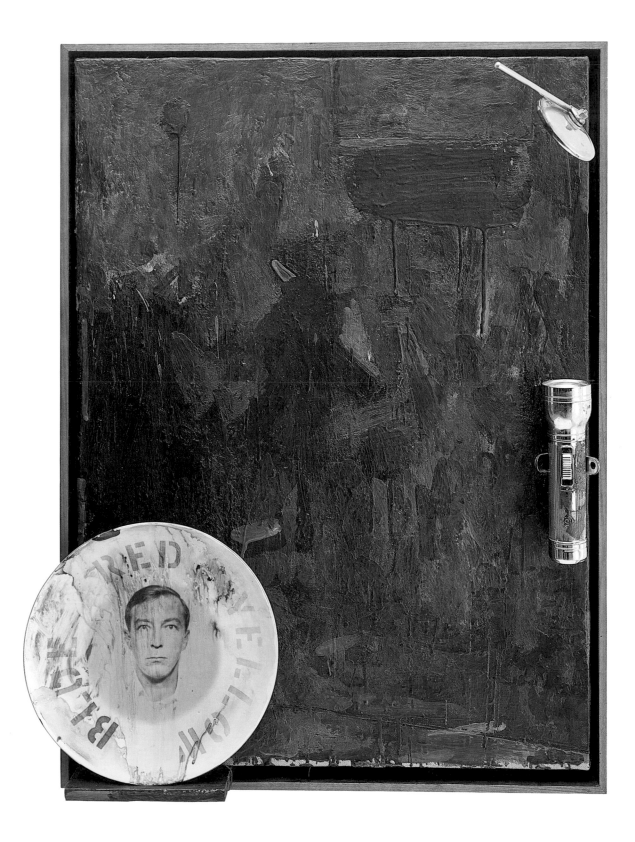

◄ 5 No. 1961
 Nein. 172,7 × 101,6 cm

9 Souvenir. 1964
 Souvenir. 73 × 53,3 cm

8 Field Painting. 1963–64
Feldgemälde. 182,9 × 93,3 cm

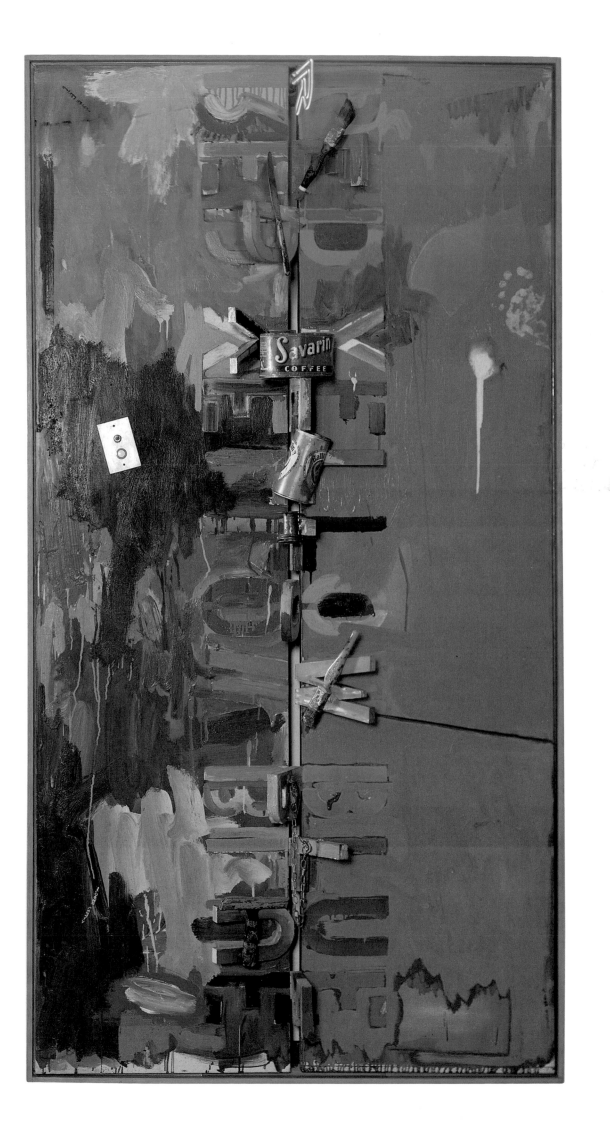

7 Periscope (Hart Crane). 1963
Periskop (Hart Crane). 170,2 × 121,9 cm

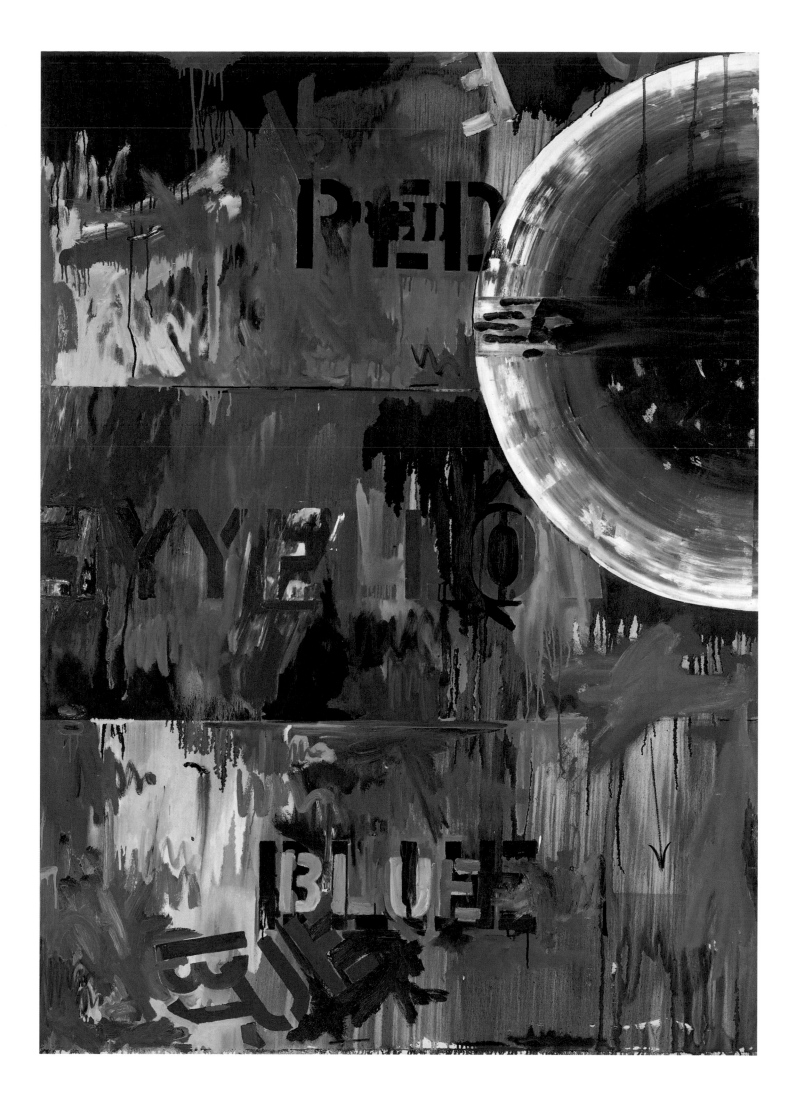

37 Study for Skin IV. 1962
Studie für Haut IV. 55,9 × 86,4 cm

34 Study for Skin I. 1962 ►
Studie für Haut I. 55,9 × 86,4 cm

35 Study for Skin II. 1962 ►
Studie für Haut II. 55,9 × 86,4 cm

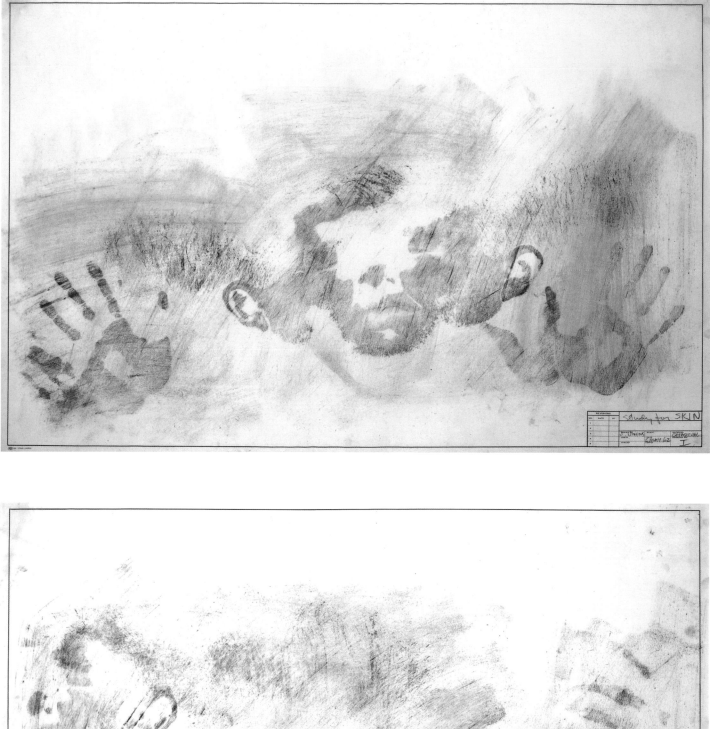

39 Skin I. 1973
 Haut I. 64,8 × 102,2 cm

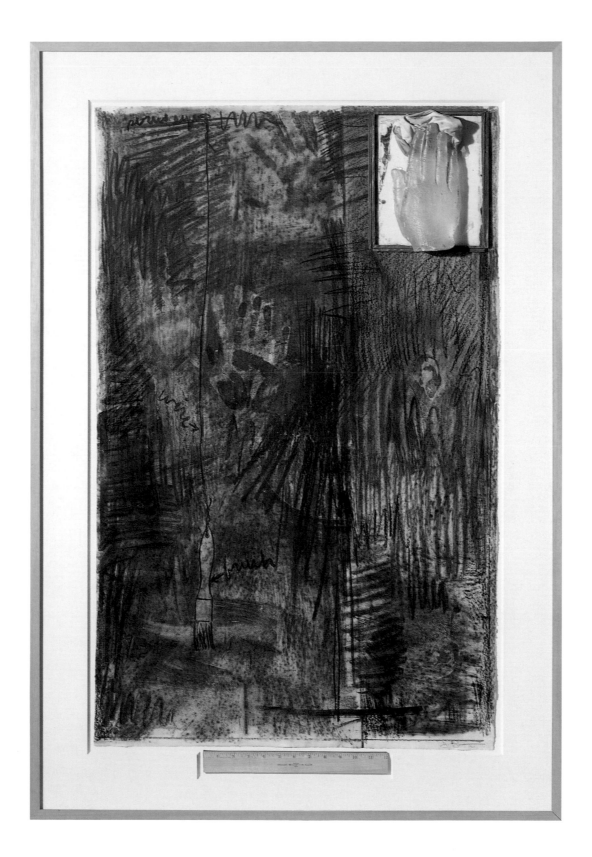

38 Wilderness II. 1963
Wildnis II. 127 × 87,3 cm

10 Wall Piece. 1968
Wand-Arbeit. 182,9 × 280 cm

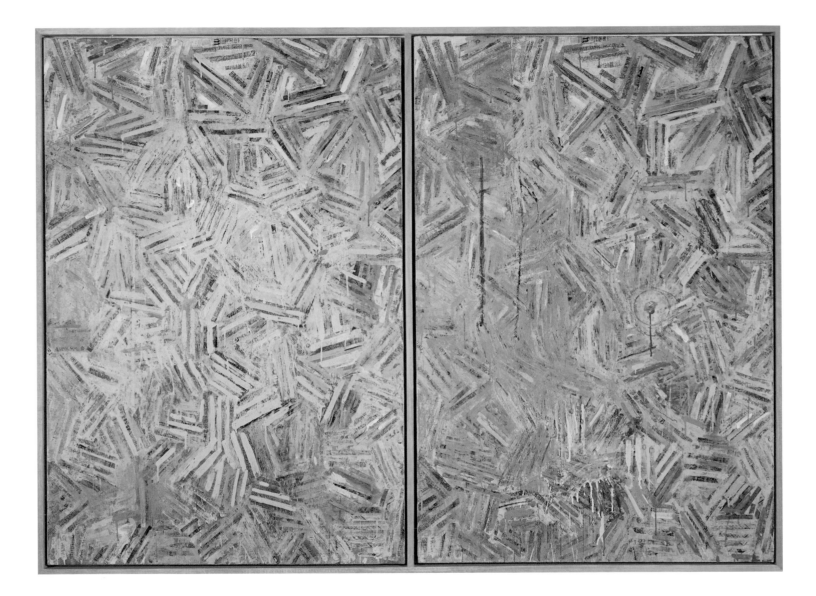

12 The Dutch Wives. 1975
 Die holländischen Frauen. 131,4 × 180,3 cm

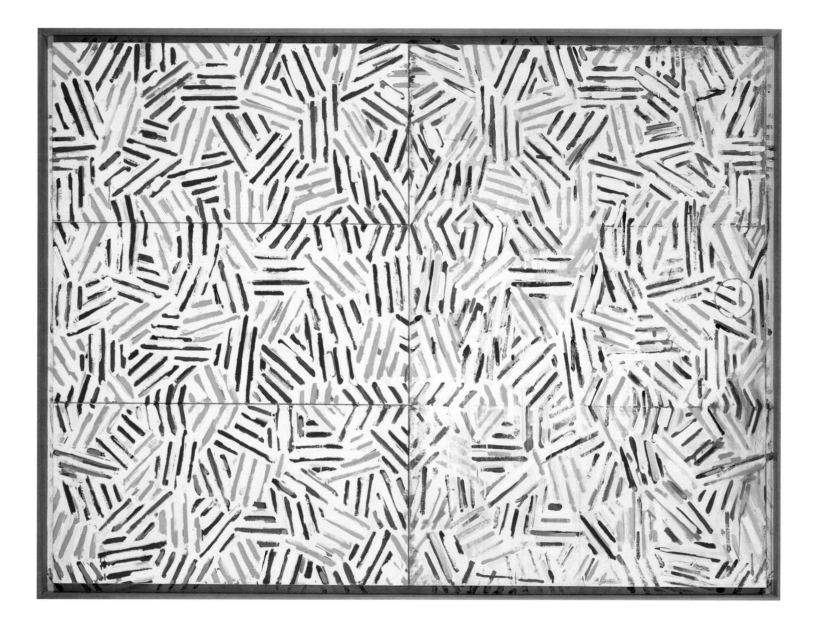

11 Corpse and Mirror II. 1974–75
Leichnam und Spiegel II. 146,4 × 191,1 cm

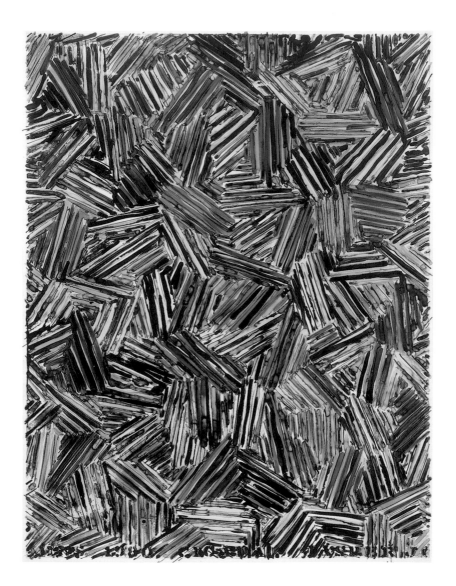

45 Cicada. 1980
 Zikade. 86,4 × 65,4 cm

18 In the Studio. 1982 ▶
 Im Atelier. 182,9 × 121,9 cm

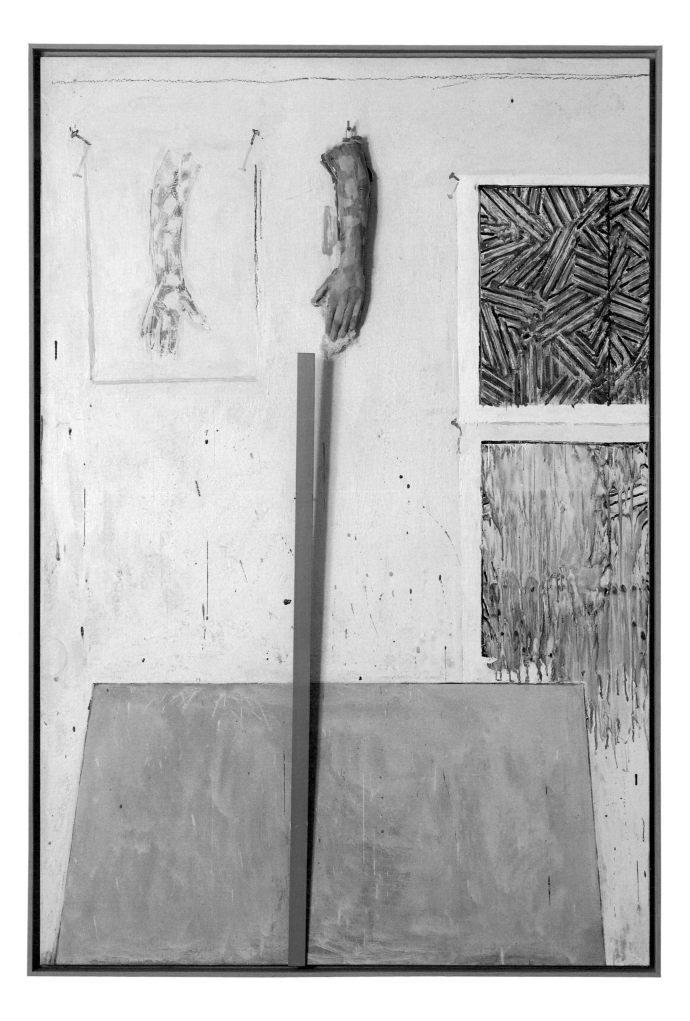

13 Dancers on a Plane. 1979
 Tänzer auf einer Ebene. 197,8 × 162,6 cm

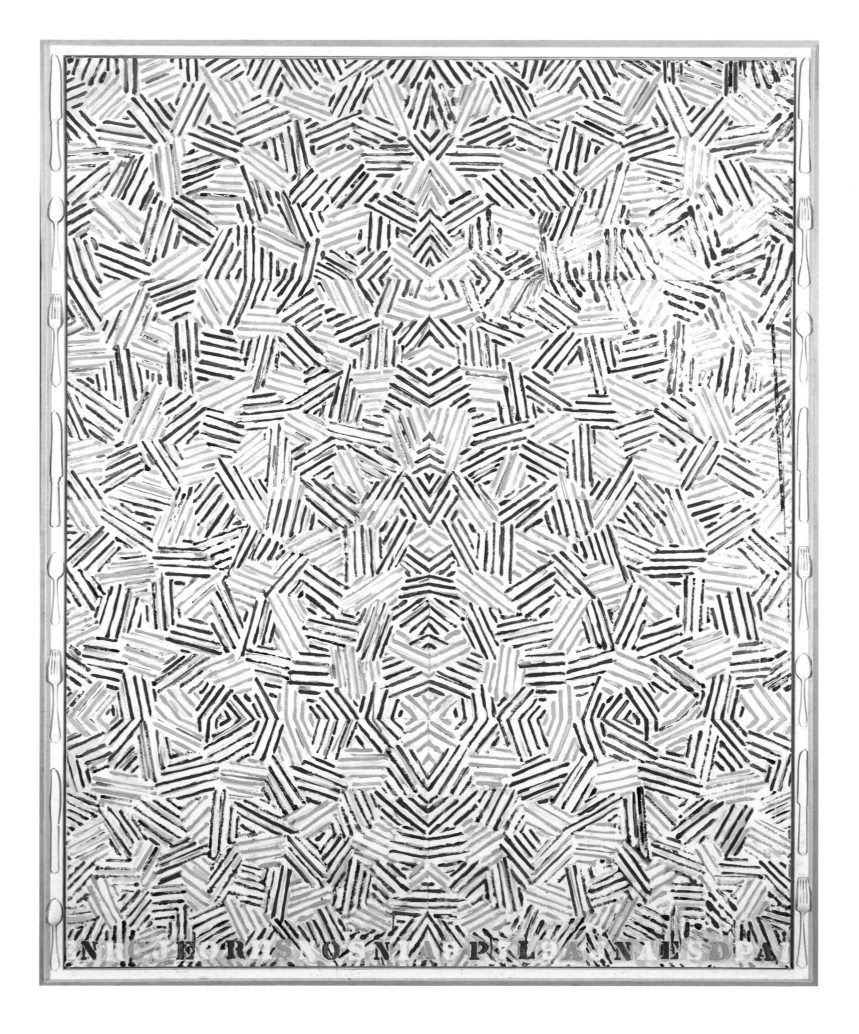

43 Cicada. 1979
 Zikade. 109,2 × 73 cm

46 Tantric Detail. 1980
Tantrisches Detail. 147,3 × 104,1 cm

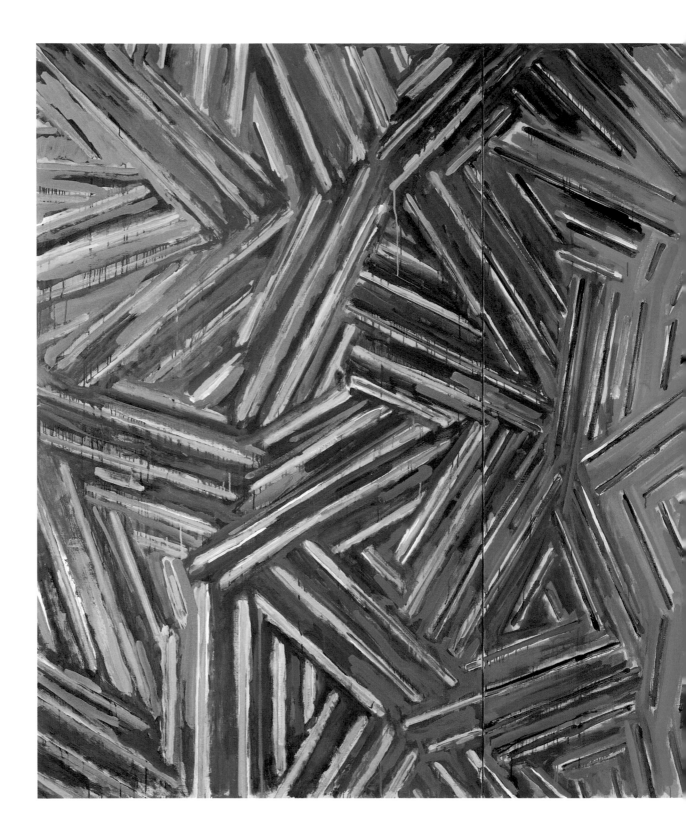

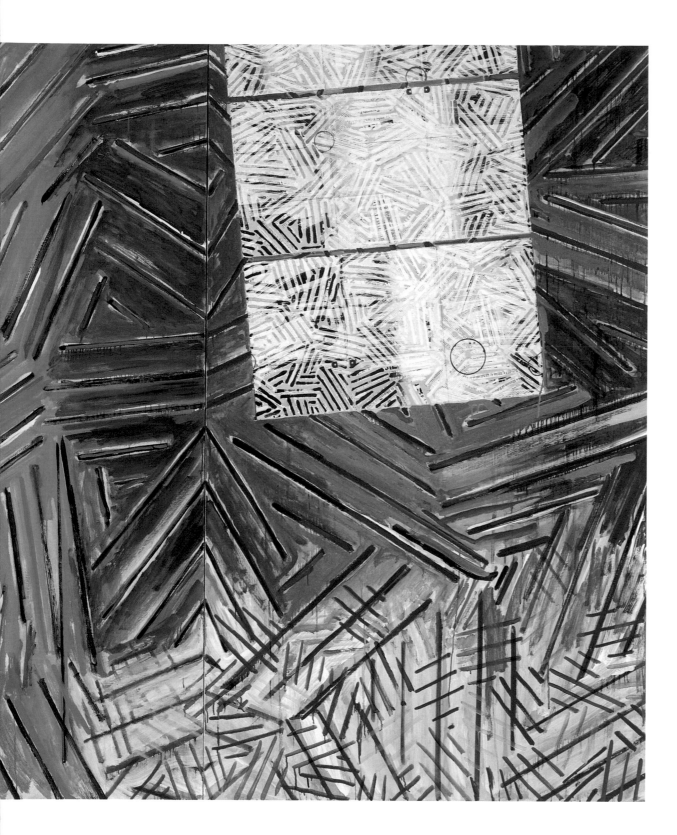

14 Between the Clock and the Bed. 1981
Zwischen Uhr und Bett. 182,9 × 320,7 cm

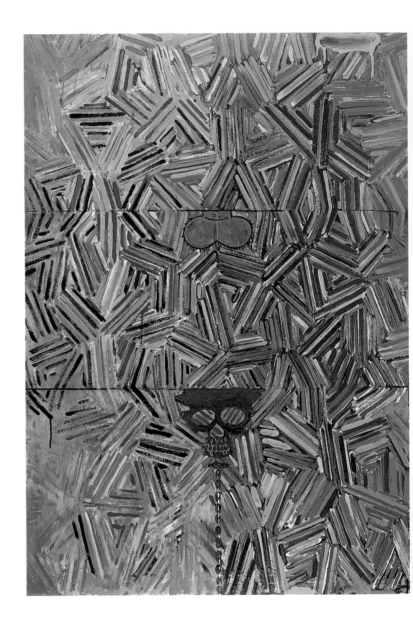

15 Tantric Detail I. 1980
Tantrisches Detail I. 127,3 × 86,7 cm

16 Tantric Detail II. 1981
Tantrisches Detail II. 127 × 86,4 cm

17 Tantric Detail III. 1981
Tantrisches Detail III. 127 × 86,4 cm

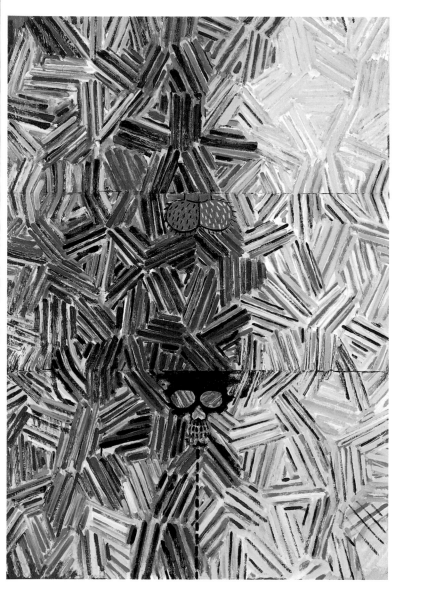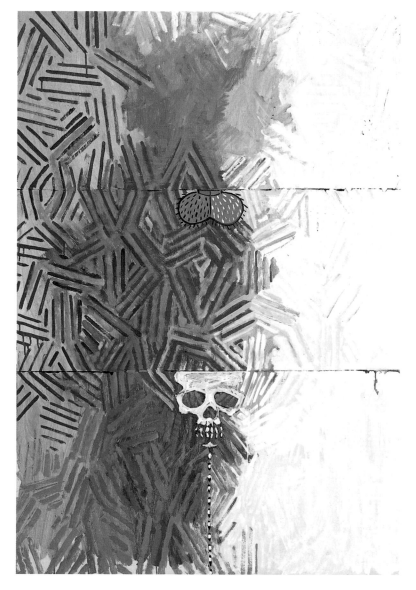

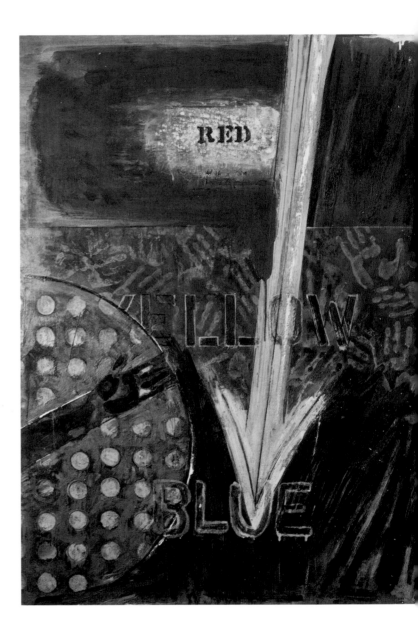

19 Untitled (Red, Yellow, Blue). 1984
 Ohne Titel (Rot, Gelb, Blau). 140,3 × 300,9 cm

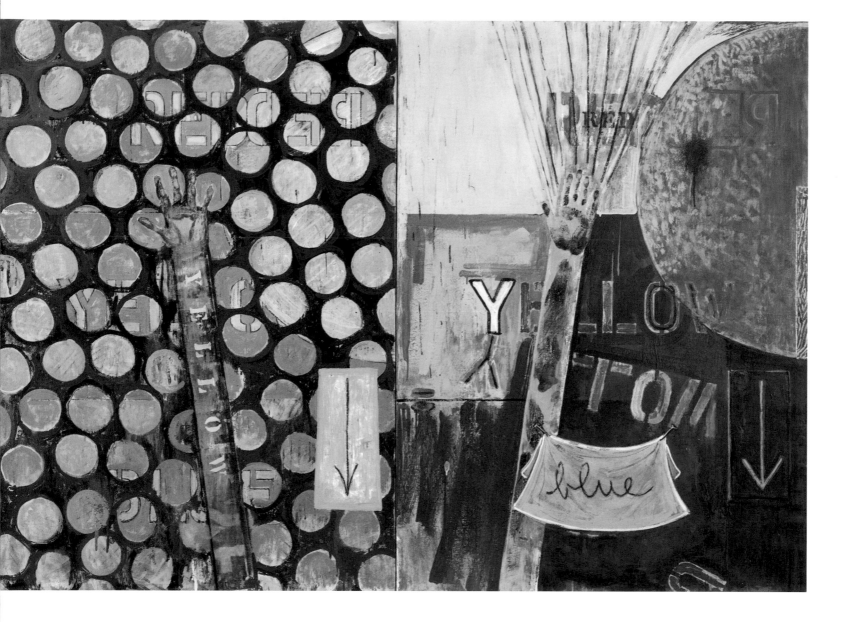

47 Untitled. 1988
Ohne Titel. 67,3 × 49,5 cm

21 Fall. 1986 ▶
Herbst. 190,5 × 127 cm

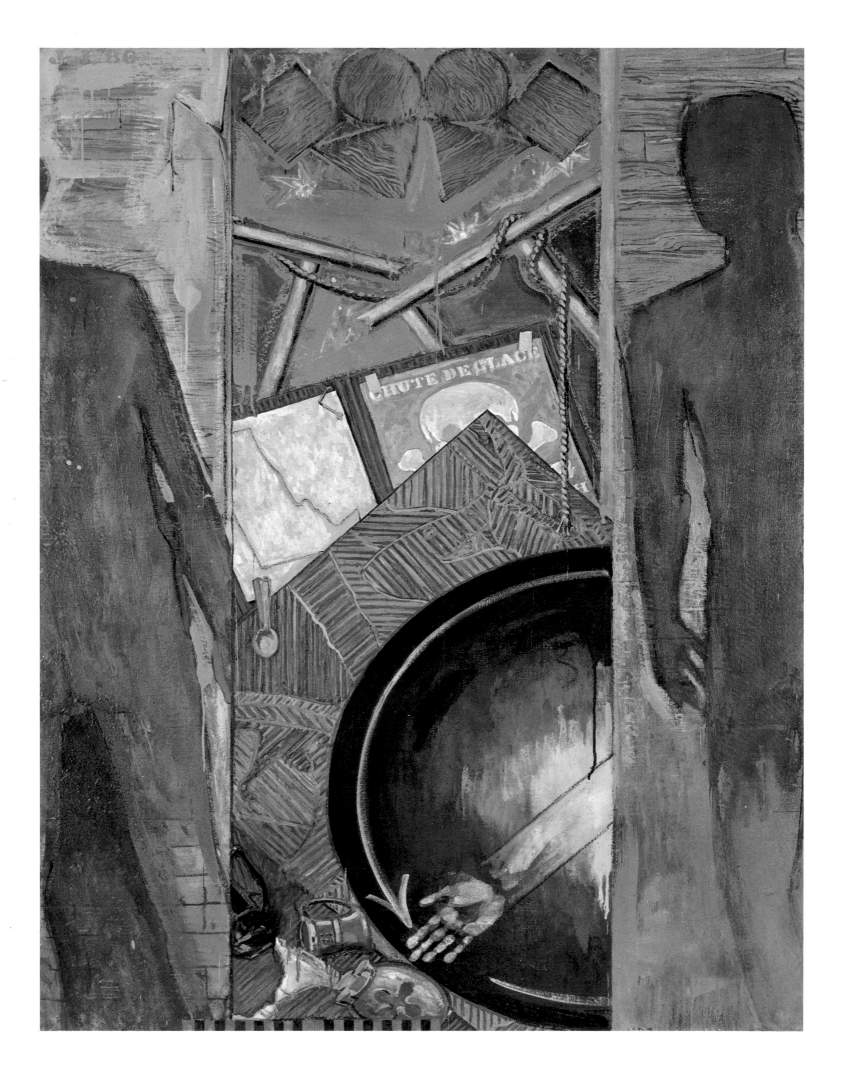

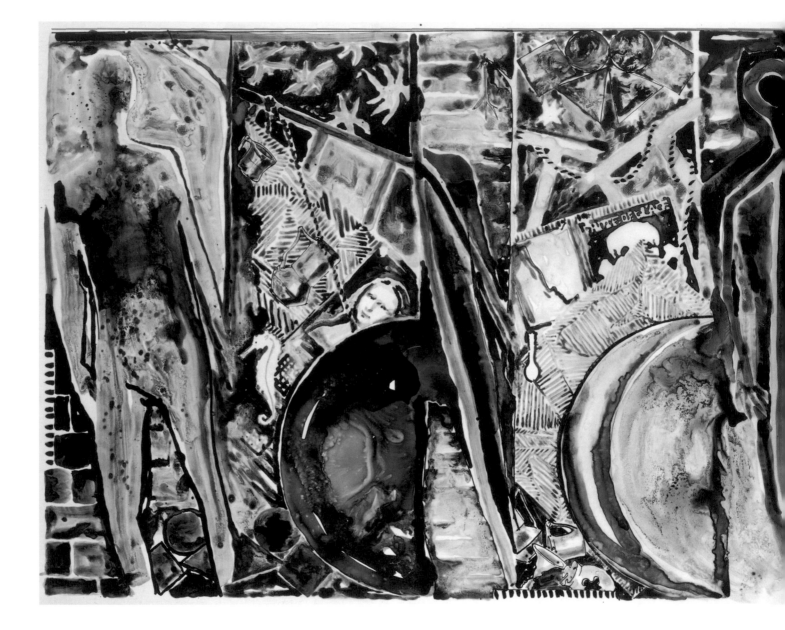

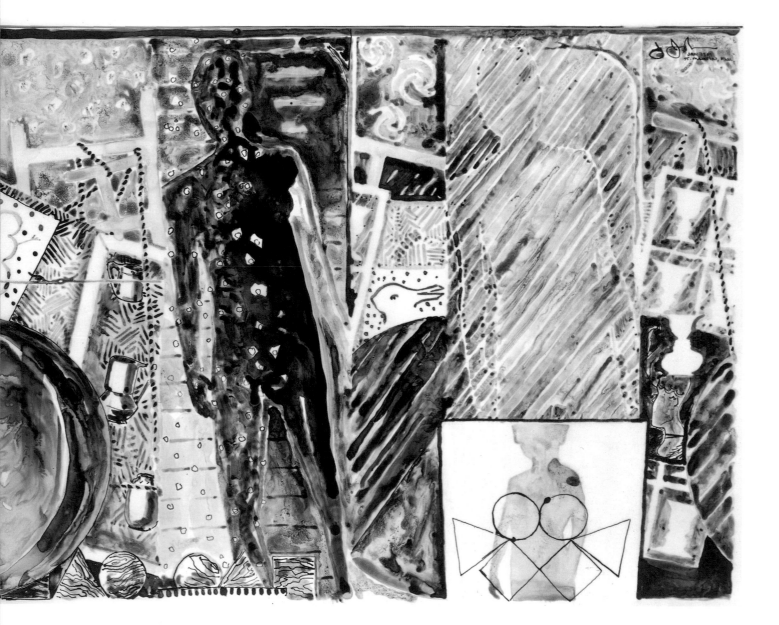

49 The Seasons. 1989
Die Jahreszeiten. 66 × 147,3 cm

20 Untitled. 1984
Ohne Titel. 127×190,5 cm

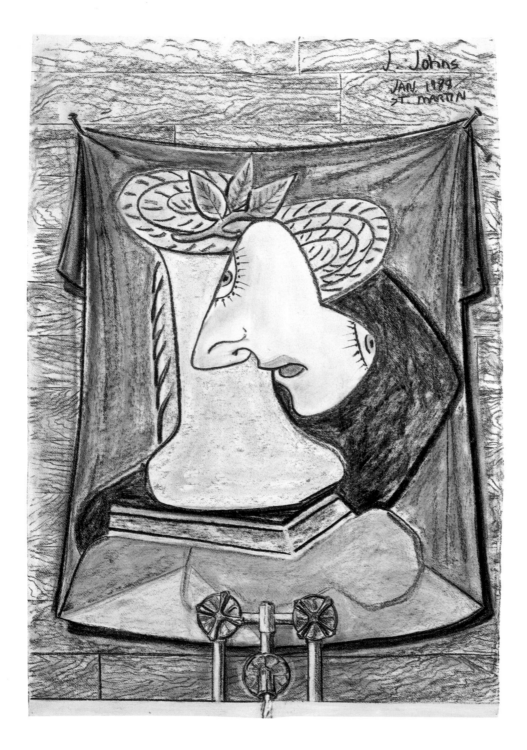

48 Untitled. 1988
 Ohne Titel. 97,8 × 68,9 cm

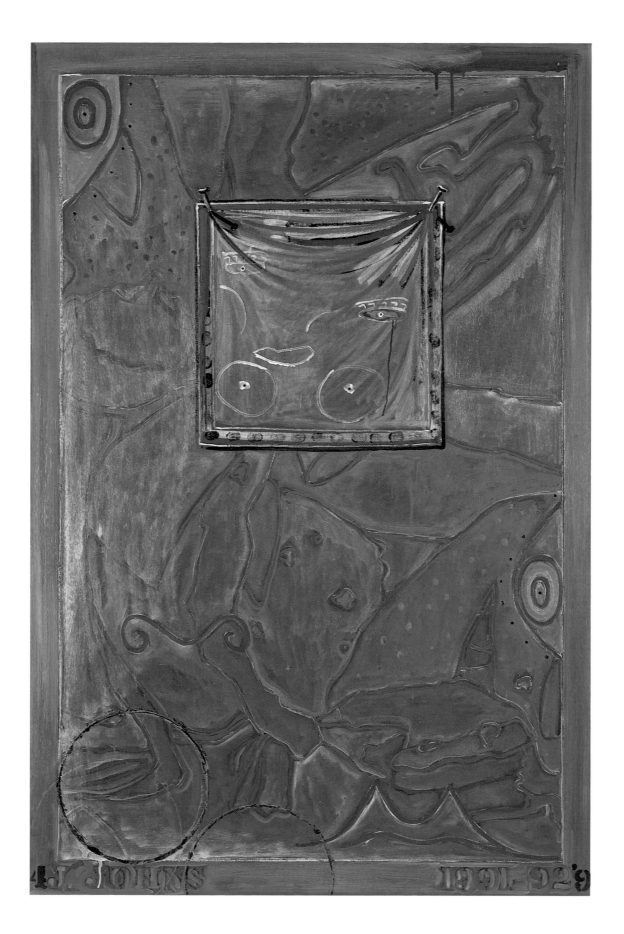

26 Untitled. 1991–94
Ohne Titel. 153 × 101,6 cm

50 Untitled. 1990
Ohne Titel. 109,2 × 71,2 cm

23 Untitled. 1990 ▶
Ohne Titel. 190,5 × 127 cm

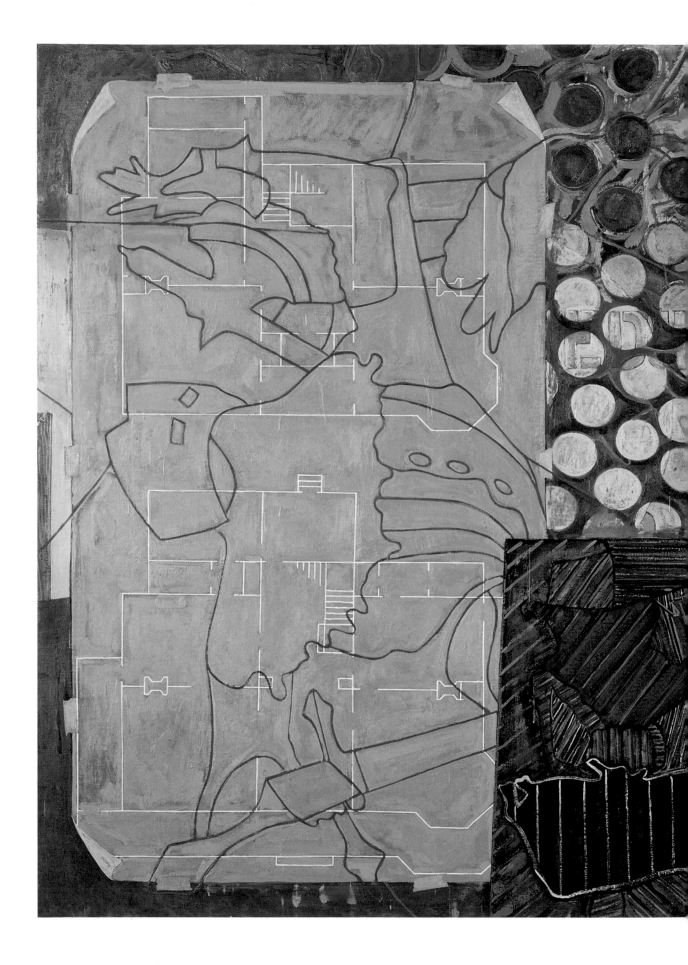

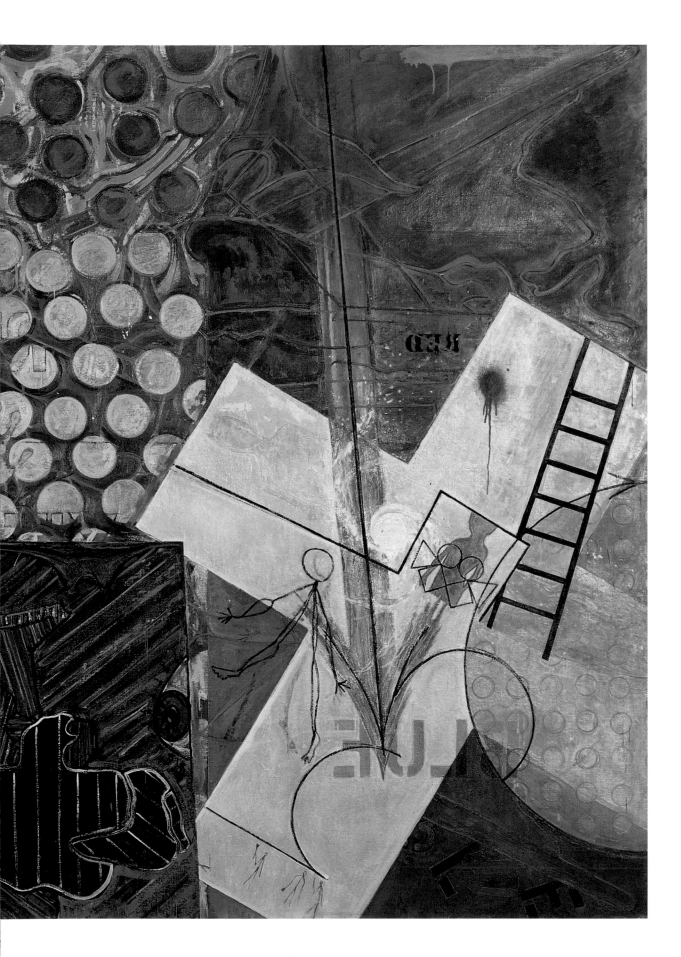

27 Untitled. 1992–94
Ohne Titel. 198,1 × 299,7 cm

51 Nothing at All Richard Dadd. 1992
 Gar nichts Richard Dadd. 104,7 × 69,8 cm

Bilder/Paintings

1 Figure 5
Ziffer 5
1955
Enkaustik und Collage auf Leinwand
44,5 × 35,6 cm, 17½″ × 14″

2 White Flag
Weisse Flagge
1955
Enkaustik und Collage auf Leinwand (drei Teile)
198,9 × 306,7 cm, 78⁵⁄₁₆″ × 120¾″

3 Canvas
Leinwand
1956
Enkaustik und Collage auf Holz und Leinwand
76,3 × 63,5 cm, 30″ × 20″

4 Painting with two Balls
Gemälde mit zwei Kugeln
1960
Enkaustik und Collage auf Leinwand mit Objekten
(drei Teile)
165,1 × 137,2 cm, 65″ × 54″

5 No
Nein
1961
Enkaustik, Collage und skulptiertes Metall
auf Leinwand mit Objekten
172,7 × 101,6 cm, 68″ × 40″

6 Painting bitten by a Man
Gemälde, von Mann gebissen
1961
Enkaustik auf Leinwand
24,1 × 17,5 cm, 9½″ × 6⅞″

7 Periscope (Hart Crane)
Periskop (Hart Crane)
1963
Öl auf Leinwand
170,2 × 121,9 cm, 67″ × 48″

8 Field Painting
Feldgemälde
1963–64
Öl auf Leinwand mit Objekten (2 Teile)
182,9 × 93,3 cm, 72″ × 36¾″

9 Souvenir
Souvenir
1964
Enkaustik auf Leinwand mit Objekten
73 × 53,3 cm, 28¾″ × 21″

10 Wall Piece
Wand-Arbeit
1968
Öl und Collage auf Leinwand (drei Teile)
182,9 × 280 cm, 72″ × 110¼″

11 Corpse and Mirror II
Leichnam und Spiegel II
1974–75
Öl auf Leinwand (vier Teile)
146,4 × 191,1 cm, 57⅝″ × 75¼″

12 The Dutch Wives
Die holländischen Frauen
1975
Enkaustik und Collage auf Leinwand (zwei Teile)
131,4 × 180,3 cm, 51¾″ × 71″

13 Dancers on a Plane
Tänzer auf einer Ebene
1979
Öl auf Leinwand mit Objekten
197,8 × 162,6 cm, 77⅛″ × 64″

14 Between the Clock and the Bed
Zwischen Uhr und Bett
1981
Öl auf Leinwand (drei Teile)
182,9 × 320,7 cm, 72″ × 126¼″

15 Tantric Detail I
Tantrisches Detail I
1980
Öl auf Leinwand
127,3 × 86,7 cm, 50⅛″ × 34⅛″

16 Tantric Detail II
Tantrisches Detail II
1981
Öl auf Leinwand
127 × 86,4 cm, 50″ × 34″

17 Tantric Detail III
Tantrisches Detail III
1981
Öl auf Leinwand
127 × 86,4 cm, 50″ × 34″

18 In the Studio
Im Atelier
1982
Enkaustik und Collage auf Leinwand mit Objekten
182,9 × 121,9 cm, 72″ × 48″

19 Untitled (Red, Yellow, Blue)
Ohne Titel (Rot, Gelb, Blau)
1984
Enkaustik auf Leinwand (drei Teile)
140,3 × 300,9 cm, 55¼″ × 118½″

20 Untitled
Ohne Titel
1984
Enkaustik auf Leinwand
127 × 190,5 cm, 50″ × 75″

21 Fall
Herbst
1986
Enkaustik auf Leinwand
190,5 × 127 cm, 75″ × 50″

22 Untitled
Ohne Titel
1990
Öl auf Leinwand
80,3 × 104,1 cm, 31⅝″ × 41″

23 Untitled
Ohne Titel
1990
Öl auf Leinwand
190,5 × 127 cm, 75″ × 50″

24 Untitled
Ohne Titel
1991
Öl auf Leinwand
152,4 × 101,6 cm, 60″ × 40″

25 Untitled
Ohne Titel
1991
Enkaustik auf Leinwand
152,4 × 101,6 cm, 60″ × 40″

26 Untitled
Ohne Titel
1991–94
Öl auf Leinwand
153 × 101,6 cm, 60¼″ × 40″

27 Untitled
Ohne Titel
1992–94
Enkaustik auf Leinwand
198,1 × 299,7 cm, 78″ × 118″
Courtesy of the Eli and Edythe
L. Broad Collection, Los Angeles

Arbeiten auf Papier/Works on paper

28 Flag
Flagge
1955
Graphitstift und Feuerzeugbenzin(?) auf Papier
21,5 × 25,7 cm, 8½″ × 10⅛″

29 Target with Four Faces
Zielscheibe mit vier Gesichtern
1955
Bleistift und Pastell auf Papier
23,5 × 20 cm, 9¼″ × 7⅛″

30 Flag
Flagge
1957
Graphitstift auf Papier
27,6 × 38,8 cm, 10⅞″ × 15¹⁵⁄₁₆″

31 Study for "Painting with a Ball"
Studie für «Gemälde mit Kugel»
1958
Conté-Kreide auf Papier
50,8 × 45,7 cm, 20″ × 18″

32 Thermometer
Thermometer
1960
Kohle und Pastell auf Zeichenpapier
55,9 × 27,6 cm, 22¼″ × 16½″

33 Two Flags
Zwei Flaggen
1960
Graphit, laviert, auf Papier
74,9 × 55,2 cm, 29½″ × 21¾″

34 Study for Skin I
Studie für Haut I
1962
Kohle auf Zeichenpapier
55,9 × 86,4 cm, 22″ × 34″

35 Study for Skin II
Studie für Haut II
1962
Kohle auf Zeichenpapier
55,9 × 86,4 cm, 22″ × 34″

36 Study for Skin III
Studie für Haut III
1962
Kohle auf Zeichenpapier
55,9 × 86,4 cm, 22″ × 34″

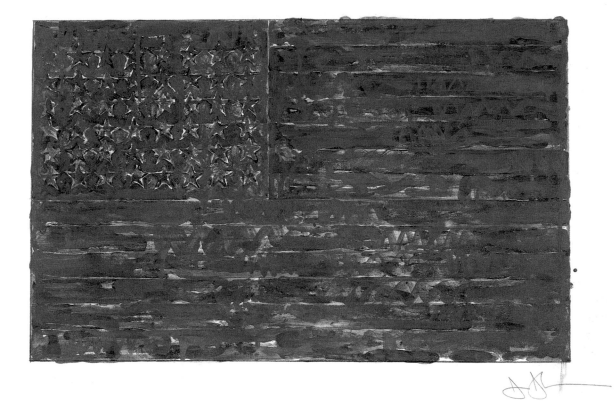

52 Flag. 1972–94
Flagge. 44,5 × 59,7 cm

37 Study for Skin IV
Studie für Haut IV
1962
Kohle auf Zeichenpapier
55,9 × 86,4 cm, 22″ × 34″

38 Wilderness II
Wildnis II
1963
Kohle, Pastell und Collage auf Papier mit Objekten
127 × 87,3 cm, 50″ × 34⅜″

39 Skin I
Haut I
1973
Kohle auf Papier
64,8 × 102,2 cm, 25½″ × 40¼″

40 Skin II
Haut II
1973
Kohle auf Papier
64,8 × 102,2 cm, 25½″ × 40¼″

41 Tracing
Konturzeichnung
1978
Tusche auf Kunststoff
59,6 × 40,6 cm, 20⅜″ × 12¾″

42 Untitled
Ohne Titel
1978
Acryl auf Papier
111,1 × 73,7 cm, 43¾″ × 29″

43 Cicada
Zikade
1979
Aquarell, Buntstift und Graphitstift auf Papier
109,2 × 73 cm, 43″ × 28¾″

44 Untitled
Ohne Titel
1979–84
Acryl und Bleistift auf Papier
76,6 × 57,2 cm, 30¼″ × 22½″

45 Cicada
Zikade
1980
Tusche auf Kunststoff
86,4 × 65,4 cm, 34″ × 25¾″

46 Tantric Detail
Tantrisches Detail
1980
Kohle auf Papier
147,3 × 104,1 cm, 58″ × 41″

47 Untitled
Ohne Titel
1988
Tusche auf Kunststoff
67,3 × 49,5 cm, 26½″ × 19½″

48 Untitled
Ohne Titel
1988
Kohle und Pastell auf Papier
97,8 × 68,9 cm, 38½″ × 27⅛″

49 The Seasons
Die Jahreszeiten
1989
Tusche auf Kunststoff
66 × 147,3 cm, 26″ × 58″

50 Untitled
Ohne Titel
1990
Aquarell und Tusche auf Papier
109,2 × 71,2 cm, 43″ × 28″

51 Nothing at All Richard Dadd
Gar nichts Richard Dadd
1992
Graphitstift auf Papier
104,7 × 69,8 cm, 41¼″ × 27½″

52 Flag
Flagge
1972–94
Bleistift auf Papier
44,5 × 59,7 cm, 17⅛″ × 23½″

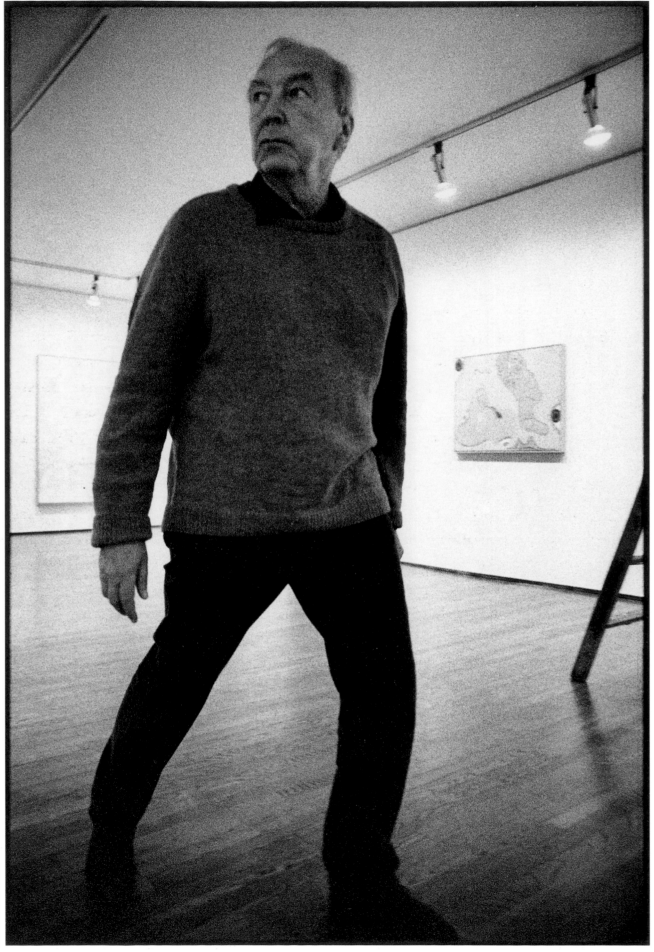

BIOGRAFIE

Jasper Johns wird am 15. Mai 1930 in Augusta, Georgia, geboren und verbringt seine Kindheit bei seinen Grosseltern und anderen Verwandten in South Carolina. Nach Studien an der University of South Carolina in Columbia geht er 1949 nach New York. Hier besucht er während kurzer Zeit eine Kunstschule, bevor er in die Armee eingezogen und in Japan stationiert wird. Ab 1952 lebt er im Stadtzentrum von New York, wo er, um seinen Lebensunterhalt zu bestreiten, in einer Buchhandlung arbeitet und Schaufensterdekorationen gestaltet, so unter anderem für Tiffany & Co.

Die ersten *Flaggen-, Zielscheiben-* und *Ziffern-gemälde* entstehen Mitte der 50er Jahre und werden 1958 an seiner ersten Einzelausstellung in der Leo Castelli Gallery in New York gezeigt, wo er auch später regelmässig ausstellt. 1959 beteiligt er sich an der Ausstellung "Sixteen Americans" im Museum of Modern Art in New York. In dieser Zeit macht Johns die ersten Plastiken einer Glühbirne und einer Taschenlampe, und 1960 entstehen die beiden Werke *Painted Bronze* (Bemalte Bronze) mit den Ballantine-Bierdosen und der Savarin-Kaffeedose mit Pinseln.

Ebenfalls 1960 entsteht in Tatyana Grosmans Werkstatt Universal Limited Art Editions (ULAE) Johns' erste Lithografie *(Target)* (Zielscheibe). Von diesem Moment an stellt er vorwiegend bei ULAE; Simca Print Artists, Inc., New York; Gemini G.E.L., Los Angeles, und Atelier Crommelynck, Paris, Druckgrafiken her. Ausstellungen seiner Druckgrafiken finden 1970 im Philadelphia Museum of Art und im Museum of Modern Art in New York und 1982 im Whitney Museum of American Art statt. Im Mai 1986 präsentiert das Museum of Modern Art die Ausstellung «Jasper Johns: A Print Retrospective», die hierauf an verschiedenen Orten in den Vereinigten Staaten, in Europa und in Japan gezeigt wird, und 1990 führt das Walker Art Center in Minneapolis zwei Jahre nach dem Erwerb einer kompletten Sammlung der grafischen Arbeiten des Künstlers die Ausstellung «Jasper Johns: Printed Symbols» durch, die danach in sechs weiteren Museen in den Vereinigten Staaten und in Kanada gezeigt wird. Im Frühjahr 1994 veröffentlicht ULAE das Werkverzeichnis *The Prints of Jasper Johns 1960–1993: A Catalogue Raisonné.*

Während des grössten Teils der 60er Jahre lebt und arbeitet Jasper Johns am Riverside Drive im oberen Teil von New York City und später im Zentrum an der East Houston Street. Er besitzt ferner ein Haus in Edisto Beach, South Carolina, das 1966 von einem Feuer zerstört wird, als er in Japan weilt. Zu den Werken dieser Periode gehören die Reihe *0 through 9* (0 bis 9) (1961), die 1964 in Japan geschaffenen Gemälde *Watchman* (Wächter) und *Souvenir,* sowie die grossflächigen Werke *Diver* (Taucher) (1962), *According to What* (Bezugnehmend auf was) (1964), *Harlem Light* (1967) und *Wall Piece* (Wand-Arbeit) (1968). Johns' *Map (Based on Buckminster Fuller's Dymaxion Air Ocean World* (Weltkarte [nach Buckminster Fullers "Dymaxion Air Ocean World"]), 1967–71, ursprünglich für die Montreal Expo '67 geschaffen, wird 1971 im Museum of Modern Art gezeigt.

In einem 1972 geschaffenen grossen Gemälde *Untitled* (Ohne Titel) führt Johns das sogenannte

«Schrägschraffur»-Motiv in sein Œuvre ein. *Scent* (Duft) (1973–74) ist das erste Werk, was ausschliesslich auf dem «Schrägschraffur»-Motiv beruht, das sein Schaffen bis in die frühen 80er Jahre dominieren sollte. Während dieser Periode, 1977, führt das Whitney Museum of American Art in New York eine Retrospektive mit dem Titel «Jasper Johns» durch. Diese Ausstellung reist hierauf auch nach Kalifornien, Europa und Japan.

Anfang 1987 werden an der Johns-Ausstellung in der Leo Castelli Gallery vier Gemälde der Reihe «The Seasons» zusammen mit Zeichnungen und Druckgrafiken zum gleichen Thema gezeigt. Eine Reihe von Ende 1987 von ULAE veröffentlichten Radierungen *The Seasons* (Die Jahreszeiten) stellt in der vom Philadelphia Museum of Art nach der Eröffnung auf der Biennale von Venedig von 1988 durchgeführten Ausstellung «Jasper Johns: Work Since 1974» das neueste Werk dar. Johns ist der Hauptkünstler im Pavillon der USA in Venedig und erhält den Grossen Preis der 43. Biennale.

1990 eröffnet die National Gallery of Art in Washington D.C. die Retrospektive «The Drawings of Jasper Johns», die anschliessend auch im Kunstmuseum Basel, in der Hayward Gallery in London und im Whitney Museum of American Art in New York gezeigt wird. 1993 feiert Leo Castelli seine langjährige Beziehung zum Künstler mit einer Ausstellung «Jasper Johns: 35 Years with Leo Castelli» mit Werken, die für die von 1958 bis 1993 in dieser Galerie durchgeführten elf Ausstellungen repräsentativ sind. Anfang 1996 öffnet die vom Centre for the Study of Sculpture am Henry Moore Institute in Leeds organisierte erste Ausstellung von Johns' Plastiken in der Menil Collection in Houston ihre Tore und wird später auch in der Leeds City Art Gallery gezeigt. Im Herbst desselben Jahres zeigt das Museum of Modern Art, New York, eine Retrospektive über das Œuvre des Künstlers, die hierauf auch in Museen in Köln und in Tokio gezeigt wird.

Jasper Johns ist seit ihrer Gründung 1963 Leiter der Foundation for Contemporary Performance Arts. 1967 bis 1975 ist er künstlerischer Berater der Merce Cunningham Dance Company. 1970 erhält er von der Brandeis University die Creative Arts Awards Citation for Painting sowie von der Skowhegan School of Painting and Sculpture 1972 die Skowhegan Medal for Painting und 1977 die Skowhegan Medal for Graphics. 1973 wird er zum Mitglied des National Institute of Arts and Letters in New York ernannt und 1978 wird ihm der City of New York Mayor's Award of Honor for Arts and Culture verliehen. 1984 wird er Fellow of the American Academy of Arts and Sciences in Boston. Die American Academy and Institute of Arts and Letters verleiht Johns 1986 die Gold Medal for Graphic Art und im gleichen Jahr erhält er von der Wolf Foundation of Israel den Wolf Prize for Painting. Die Brandeis University ehrt ihn 1988 erneut mit der Creative Arts Awards Medal for Painting, und am Ende dieses Jahres wird er in die American Academy of Arts and Letters gewählt. 1990 wird Johns von Präsident Bush die National Medal of Arts verliehen, und 1993 erhält er von der Japan Art Association die Auszeichnung «Praemium Imperiale» für Malerei. 1994 verleiht ihm die MacDowell Colony, Peterborough, New Hampshire, die Edward MacDowell Medal.

Gegenwärtig verfügt Jasper Johns über Ateliers in Connecticut, New York und Französisch-Westindien, wo er an Gemälden, Zeichnungen, Plastiken und Druckgrafiken arbeitet.

BIOGRAPHY

Jasper Johns was born May 15, 1930, in Augusta, Georgia, and lived in South Carolina during his childhood with his grandparents and other relatives. After studying at the University of South Carolina, Columbia, he went to New York in 1949. He attended art school for a short time before he was drafted into the army and stationed in Japan. From 1952 he lived in downtown New York, supporting himself by working in a bookstore and making display work for stores, including Tiffany & Co.

The first *Flag, Target*, and *Number* paintings were made in the mid-1950s and were shown in his first one-man exhibition in 1958 at the Leo Castelli Gallery, New York, where he has continued to exhibit regularly. In 1959 he participated in the "Sixteen Americans" show at The Museum of Modern Art, New York. During this period, Johns made his first sculptures, of a light bulb and a flashlight; and in 1960 he made the two *Painted Bronze* pieces of the Ballantine Ale cans and the Savarin coffee can with paintbrushes.

Also in 1960, Johns made his first lithograph *(Target)* at Tatyana Grosman's print workshop on Long Island, Universal Limited Art Editions (ULAE). He has since made prints mainly at ULAE; Simca Print Artists, Inc., New York; Gemini G.E.L., Los Angeles; Atelier Crommelynck, Paris. Exhibitions of his prints were held in 1970 at the Philadelphia Museum of Art and The Museum of Modern Art, New York, and in 1982 at the Whitney Museum of American Art. In May, 1986, The Museum of Modern Art presented "Jasper Johns: A Print Retrospective," which traveled in the United States, Europe, and Japan; and in 1990, two years after having acquired a complete collection of the artist's published graphic work, the Walker Art Center, Minneapolis, organized the exhibition "Jasper Johns: Printed Symbols", which traveled to six other museums in the United States and Canada. In spring 1994 ULAE introduced *The Prints of Jasper Johns 1960–1993: A Catalogue Raisonné*.

During most of the 1960s, Jasper Johns lived and worked on Riverside Drive in upper New York City and later downtown on East Houston Street. He also had a house at Edisto Beach, South Carolina, which a fire destroyed in 1966 while he was in Japan. Works of this period include the *0 through 9* series (1961); the *Watchman* and *Souvenir* paintings, made in Japan (1964); and the large works *Diver* (1962), *According to What* (1964), *Harlem Light* (1967), and *Wall Piece* (1968). Johns' *Map (Based on Buckminster Fuller's Dymaxion Air Ocean World)*. 1967–71, originally made for the Montreal Expo '67, was shown at The Museum of Modern Art in 1971.

In a large *Untitled* painting in 1972, Johns introduced in his work a motif referred to as "cross hatch." *Scent*, 1973–74, was the first work based entirely on the "cross hatch" motif, which dominated his work into the early 1980s. During this period, in 1977, the Whitney Museum of American Art, New York, presented a retrospective exhibition, "Jasper Johns," which traveled in the United States, Europe, and Japan.

In the beginning of 1987, Johns' show at the Leo Castelli Gallery featured four paintings of "The

Seasons," along with drawings and prints based on the same theme. A set of four intaglio prints, *The Seasons*, published by ULAE at the end of 1987, represented the most recent work in the exhibition "Jasper Johns: Work Since 1974", organized by and shown at the Philadelphia Museum of Art, after opening at the 1988 Venice Biennale. Johns was the featured artist in the American Pavilion at Venice and recipient of the Grand Prize for the 43rd Biennale.

In 1990 the National Gallery of Art, Washington, D.C., opened the retrospective, "The Drawings of Jasper Johns", later shown at the Kunstmuseum Basel; the Hayward Gallery, London; and the Whitney Museum of American Art, New York. In 1993 Leo Castelli celebrated his long working relationship with the artist with an exhibition "Jasper Johns: 35 Years with Leo Castelli" with works representing the eleven shows held at the gallery from 1958 to 1993. Early in 1996, the first exhibition of Johns' sculpture, organized by The Centre for the Study of Sculpture at the Henry Moore Institute in Leeds, opened at The Menil Collection, Houston, and was later shown at the Leeds City Art Gallery. In the fall of the same year, The Museum of Modern Art, New York, presented a retrospective exhibition of the artist's work, which traveled to museums in Cologne and Tokyo.

Jasper Johns has been a Director of the Foundation for Contemporary Performance Arts since its beginning in 1963. He was Artistic Advisor to the Merce Cunningham Dance Company from 1967 to 1975. He received the Creative Arts Awards Citation for Painting from Brandeis University in 1970 and two medals from the Skowhegan School of Painting and Sculpture: the Skowhegan Medal for Painting in 1972 and the Skowhegan Medal for Graphics in 1977. In 1973 he was elected a Member of the National Institute of Arts and Letters, New York, and in 1978 he received the City of New York Mayor's Award of Honor for Arts and Culture. He became a Fellow of the American Academy of Arts and Sciences, Boston, in 1984. The American Academy and Institute of Arts and Letters awarded Johns the Gold Medal for Graphic Art in 1986, the same year in which the Wolf Foundation of Israel awarded him the Wolf Prize for Painting. Brandeis University honored him again in 1988 with the Creative Arts Awards Medal for Painting, and at the end of the year he was elected to the American Academy of Arts and Letters. In 1990 Johns received the National Medal of Arts from President Bush and in 1993 the Praemium Imperiale for painting from the Japan Art Association in Tokyo. The MacDowell Colony, Peterborough, New Hampshire, awarded Johns the Edward MacDowell Medal in 1994.

At present, Jasper Johns maintains studios in Connecticut, New York and the French West Indies, where he works on paintings, drawings, sculptures and prints.

Wichtige Einzelausstellungen
Important one-man exhibitions

1958 "Jasper Johns Paintings", Leo Castelli Gallery,
New York, January 20 – February 8.

1959 Galerie Rive Droite, Paris, January – March.

Galleria d'Arte del Naviglio, Milan, March 21–30.

1960 "Jasper Johns", Leo Castelli Gallery, New York,
February 15 – March 5.

"Paintings by Jasper Johns", University Gallery,
University of Minneapolis, Minnesota, May 3 – June 15.

"Jasper Johns 1955–1960", Columbia Museum of Art,
South Carolina, December 7–29. Cat.

1961 "Jasper Johns: Drawings and Sculpture", Leo Castelli
Gallery, New York, January 31 – February 25.

1962 Galerie Ileana Sonnabend, Paris.

1963 "Jasper Johns", Leo Castelli Gallery, New York,
January 12 – February 7.
Jasper Johns is exclusively represented by Leo Castelli
Gallery where he continues to be shown.

1964 "Jasper Johns", The Jewish Museum, New York,
February 16 – April 12. Cat.

"Jasper Johns: Paintings, Drawings and Sculpture
1954–1964", Whitechapel Gallery, London, December. Cat.

1965 "Jasper Johns, Retrospective", Pasadena Art Museum,
California, January 26 – February 28. Cat.

Minami Gallery, Tokyo. Cat.

1966 "Jasper Johns", Leo Castelli Gallery, New York,
January 8 – February 2.

"The Drawings of Jasper Johns", National Collection
of Fine Arts at the Smithsonian Institution, Washington,
D.C., October 6 – November 13. Cat.

1967 "Jasper Johns 0–9", Minami Gallery, Tokyo,
June 26 – July 22.

1968 "Jasper Johns", Leo Castelli Gallery, New York,
February 24 – March 16.

"Jasper Johns: Lithographer", Documenta IV, Kassel,
June 17 – October 6; Louisiana Museum, Humleback,
November 20 – January 12, 1969; Kunstmuseum, Basel,
February 1 – March 9, 1969; Moderna Galerija
(8th International Exhibition of Graphic Art), Ljubljana,
June 6 – August 31, 1969; Museum of Modern Art,
Belgrade, September 5–28, 1969; National Gallery of
Prague, October 23 – December 23, 1969; Museum Sztuki
w Lodzi, Lodz, February 28 – March 31, 1970; Romanian
Athenaeum, Bucharest, August 26 – September 15, 1970.

1969 "Jasper Johns: Lead Reliefs", Gemini G.E.L.,
Los Angeles, April. Cat.

"Jasper Johns: Lead Reliefs", Leo Castelli Gallery,
May 10–29.

"Jasper Johns: The Graphic Work", Marion Koogler
McNay Art Institute, San Antonio, July 6 – August 6;
Pollock Galleries, Southern Methodist University, Dallas,
September 14 – October 12; University Art Museum,
University of New Mexico, Albuquerque, October 27 –
November 23; Des Moines Art Center, December 6 –
January 4, 1970. Cat.

1970 "Jasper Johns: Prints 1960–1970", Philadelphia Museum
of Art, Philadelphia, April 15 – June 14. Cat.

"Jasper Johns: Lithographer", The Museum of Modern
Art, New York, December 22 – May 3, 1971; Albright-
Knox Art Gallery, Buffalo, NY, July 15 – August 31; Tyler
Museum of Art, TX, September 20 – October 31; The San
Francisco Museum of Art, November 22 – January 2,
1972; The Baltimore Museum of Art, January 24 –
March 5; The Virginia Museum of Fine Arts, Richmond,
March 17 – April 16; The Museum of Fine Arts, Houston,
May 15 – June 25, 1972. Cat.

1971 Museum of Contemporary Art, Chicago.

Installation of *Map (Based on Buckminster Fuller's
Dymaxion Airocean World)*, 1967–71, Minneapolis Insti-
tute of the Arts, March; Marion Koogler MacNay Art
Institute, San Antonio, TX; The Museum of Modern Art,
New York.

1972 Museum of Fine Arts, Houston.

"30 Lithographs 1960–68", Circulating Exhibition,
The Museum of Modern Art, New York.

1974 "Jasper Johns Drawings", organized by the Arts Council
of Great Britain: Museum of Modern Art, Oxford,
September 7 – October 13; Mappin Art Gallery, Sheffield,
October 19 – November 17; Herbert Art Gallery, Coventry,
November 30 – December 29; Walker Art Gallery,
Liverpool, January 4 – February 2, 1975, City Art Gallery,
Leeds, February 8 – March 9; Serpentine Gallery,
London, March 20 – April 20, 1975. Cat.

1975 "Jasper Johns Drawings", Minami Gallery, Tokyo;
American Center, Kyoto, October 27 – November 15. Cat.

1976 "Jasper Johns: MATRIX 20", Wadsworth Atheneum,
Hartford, May 13 – July 6. Cat.

1977 "Japser Johns", Whitney Museum of American Art, New
York, October 17 – January 22, 1978; Museum Ludwig,
Cologne, February 10 – March 26; Musée National d'Art
Moderne, Paris, April 18 – June 4; Hayward Gallery,
London, June 21 – July 30; The Seibu Museum of Art,
Tokyo, August 19 – September 26; San Francisco Museum
of Modern Art, October 20 – December 10, 1978. Cat.

"Foirades/Fizzles", Whitney Museum of American Art,
New York, October 11 – November 20. Cat.

1978 "Jasper Johns: First Etchings", Museum of Fine Arts, Boston, January 14 – March 12.

"Jasper Johns: Prints 1970–1977, Center for the Arts, Wesleyan University, Middletown, CT, March 27 – April 25; Springfield Museum of Fine Arts, MA, May 10 – June 25; Baltimore Museum of Art, July 11 – August 20; Dartmouth College Museum and Galleries, Hopkins Center, Hanover, NH, September 8 – October 15; University Art Museum, University of California, Berkeley, November 3 – December 15; Cincinnati Art Museum, January 5 – February 16, 1979; Georgia Museum of Art, University of Georgia, Athens, March 9 – April 20; The St. Louis Art Museum, MO, May 11 – June 22; Newport Harbor Art Museum, CA, July 13 – September 9; Rhode Island School of Design, Museum of Art, Providence, October 3 – November 18, 1979. Cat.

1979 "Jasper Johns: Working Proofs", Kunstmuseum, Basel, April 7 – June 2; Staatliche Graphische Sammlung, Munich, June 19 – August 5; Städtische Galerie, Stadelsches Kunstinstitut, Frankfurt, September 13 – November 11; Kunstmuseum mit Sammlung Sprengel, Hannover, November 25 – January 6, 1980; Den Kongelige Kobberstiksamling Statens Museum for Kunst, Copenhagen, January 19 – March 16; Moderna Museet, Stockholm, March 29 – May 11; Centre Cultural de la Caixa de Pensions, Barcelona, October 2 – November 2; Provinciaal Museum Begijnhof, Hasselt, November 21 – January 4, 1981; Tate Gallery, London, February 3 – March 22, 1981.

1982 "Jasper Johns: Savarin Monotypes", Whitney Museum of American Art, New York, November 10 – January 9, 1983; Dallas Museum of Art, March 31 – May 20, 1984; Moderna Galerija, Ljubljana, June 1–30; Kunstmuseum, Basel, September 14 – November 10, 1985; Sonja Henie and Niels Onstad Foundations, Oslo, December – January 1986; Heland Thorden Wetterling Galerie, Stockholm, February – March; Tate Gallery, London, May 28 – August 31, 1986.

1986 "Jasper Johns: L'Œuvre Graphique de 1960 à 1985", Fondation Maeght, St. Paul de Vence, France, May 17 – June 30. Cat.

"Jasper Johns: A Print Retrospective", The Museum of Modern Art, New York, May 20 – August 19; Schirn Kunsthalle, Frankfurt, November 22 – January 25, 1987; Centro Reina Sofia, Madrid, February 9 – April 5; Wiener Secession, Vienna, May 7 – June 6; The Fort Worth Art Museum, July 3 – September 6; Los Angeles County Museum of Art, October 1 – December 6; Japan: Hara Museum, Gunma-Ken, May 28 – July 17, 1988; National Museum of Art, Osaka, August 4 – September 6; Kitakyushu City Museum, September 12 – October 4, 1988. Cat.

1987 "Jasper Johns: The Seasons", Leo Castelli Gallery, New York, January 31 – March 7. Cat.

"Foirades/Fizzles: Echo and Allusion in the Art of Jasper Johns", Wight Art Gallery, University of California, Los Angeles, September 20 – November 15; Walker Art Center, Minneapolis, December 6 – January 31, 1988; Archer M. Huntington Gallery, University of Texas, Austin, February 15 – March 28; Yale University Art Gallery, New Haven, April 12 – June 1; High Museum of Art, Atlanta, September 6 – November 27, 1988. Cat.

1988 "The Drawings of Jasper Johns from the Collection of Toiny Castelli", Museum of Contemporary Art, Los Angeles, February 16 – March 20.

"Jasper Johns: Work Since 1974", organized by Philadelphia Museum of Art: Venice Biennale, Italy, June 26 – September 30; Philadelphia Museum of Art, October 23 – January 8, 1989. Cat.

"Jasper Johns: A Selected View in Memory of Toiny Castelli", Seattle Art Museum, WA, November 23 – January 15, 1989.

1989 "Japser Johns: The Maps", Gagosian Gallery, New York, February 1 – March 25. Cat.

"Jasper Johns: Progressive Proofs for the Lithograph *Voice 2* and Prints 1960–1988", Kunstmuseum, Basel, February 25 – April 23.

1990 "Jasper Johns: Printed Symbols", Walker Art Center, Minneapolis, February 18 – May 13; The Museum of Fine Arts, Houston, June 17 – August 19; The Fine Arts Museum of San Francisco, September 15 – November 18; The Montreal Museum of Fine Arts, December 14 – March 10, 1991; The St. Louis Art Museum, April 7 – May 27; Center for the Fine Arts, Miami, June 22 – August 18; The Denver Art Museum, September 14 – November 10, 1991. Cat.

"Prints Exhibition 1960–1989, Jasper Johns", The Seibu Museum of Art, Tokyo, March 29 – April 10.

"The Jasper Johns Prints Exhibition", organized by Japan Art & Culture Association, Tokyo: Isetan Museum of Art, Tokyo, April 26 – May 15; Isetan Department, Niigata, June 7–19; Isetan Department, Urawa, July 14–24; Isetan Department, Matsudo, August 9–14; Isetan Department, Shizuoka, August 23–28.

"The Drawings of Jasper Johns", National Gallery of Art, Washington, D.C., May 20 – July 29; Kunstmuseum, Basel, August 19 – October 28; Hayward Gallery, London, November 29 – February 3, 1991; Whitney Museum of American Art, New York, February 20 – April 7, 1991. Cat.

1992 "Jasper Johns – According to What & Watchman", Gagosian Gallery, New York, January 21 – March 14. Cat.

"Jasper Johns: Prints and Drawings 1960–1991: Tracking Human Presence on Paper", Fondation Vincent van Gogh, Arles, France, July 3 – September 30; Louisana Museum of Modern Art, Humlebaek, Denmark, October 21 – January 17, 1993. Cat.

1993 "Jasper Johns: 35 Years with Leo Castelli", Leo Castelli Gallery, New York, January 3 – February 6. Cat.

"Jasper Johns: Love and Death", National Museum of American Art, Smithsonian Institution, Washington, November – February 20, 1994.

1996 "Jasper Johns: The Sculptures", organized by The Centre for the Study of Sculpture at The Henry Moore Institute, Leeds: The Menil Collection, Houston, February 16 – March 31; Leeds City Art Gallery, England, April 18 – June 29. Cat.

"Jasper Johns Flags", Anthony d'Offay Gallery, London, June 21 – July 27. Cat.

"Jasper Johns: A Retrospective", The Museum of Modern Art, New York, October 20 – January 21, 1997; Museum Ludwig, Cologne, March 8 – June 1, 1997; Museum of Contemporary Art, Tokyo, June 28 – August 17, 1997. Cat.

Umfassendes Ausstellungsverzeichnis siehe Jasper Johns
Retrospektive by Kirk Varnedoe/Prestel Verlag, 1997
Comprehensive exhibition chronology in Jasper Johns –
A Retrospective by Kirk Varnedoe, The Museum of Modern Art

Impressum

Fondation Beyeler
Baselstrasse 77, CH-4125 Riehen/Basel
Tel. +41 61 645 97 00, Fax +41 61 645 97 19

Ausstellung

Ernst Beyeler
Markus Brüderlin (Künstlerischer Leiter)
Koordination/Coordination: Verena Formanek
Mitarbeit/Collaboration: Urs Albrecht, Claudia Neugebauer,
Bruno Guthauser, Delia Ciuha

Katalog

Redaktion und Werkverzeichnis: Verena Formanek
Grafische Gestaltung: Atelier Urs Albrecht, Basel
Englische Übersetzung: Isabel Feder
Deutsche Übersetzung: Rolf Kern
Satz: Gygax Filmsatz, Basel
Lithos: LAC AG für Kunstreproduktion, Basel
Printed by: Werner Druck AG, Basel
Für die Abbildungen: © by Pro Litteris, Zürich 1997
© Text/Essay by Robert Rosenblum, 1997

Fotonachweiss/Photograph Credits

Dorothy Zeidman, Gamma One Conversions,
Christian Baur, Robert Bayer.
Jack Shaer und Armin Linke für das Portrait-Foto
von Jasper Johns